IMAGES
of America

FLOODS OF
NORTHERN NEW JERSEY

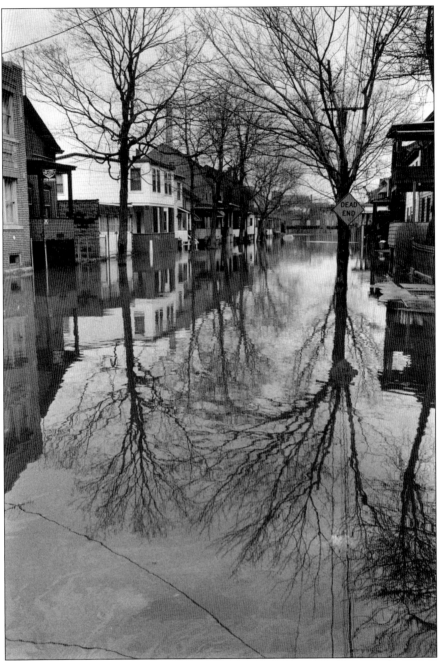

The Passaic River flooded East Holsman Street in Paterson for two days after heavy rains fell on February 1 and 2 in 1973. Usually, residents had to walk to the end of the block to see the river, but not on this day. This view looks down East Holsman Street toward the Passaic River. (Photograph by Dan Oliver; courtesy of the *Record* archives.)

ON THE COVER: Fayette Avenue in Wayne flooded in 1980. Emil Begyn woke up early in the morning to survey the damage and took a tour with *Record* photographer Peter Karas. (Photograph by Peter Karas; courtesy of the *Record* archives.)

IMAGES of America
FLOODS OF NORTHERN NEW JERSEY

Amre Youssef for
North Jersey Media Group

Copyright © 2014 by North Jersey Media Group
ISBN 978-1-4671-2087-6

Published by Arcadia Publishing
Charleston, South Carolina

Printed in the United States of America

Library of Congress Control Number: 2013943502

For all general information, please contact Arcadia Publishing:
Telephone 843-853-2070
Fax 843-853-0044
E-mail sales@arcadiapublishing.com
For customer service and orders:
Toll-Free 1-888-313-2665

Visit us on the Internet at www.arcadiapublishing.com

This book is dedicated to the victims of North Jersey who have been affected physically, financially, and emotionally by the ongoing flooding in our region and to the heroes who have risked their lives to save their fellow citizens.

Contents

Acknowledgments		6
Introduction		7
1.	History of Flooding in North Jersey	9
2.	Floods of 2010	79
3.	Floods of 2011	93
4.	Hurricane Irene	101
5.	Hurricane Sandy	115
About the Organization		126

Acknowledgments

Thanks to all the people who provided their valuable skills to complete this book. Special thanks go to Zhanna Gitina for her tireless efforts in scanning and reproducing the historical images that appear in this book and to Glenn Garvie for editing.

Thanks also go to Donna Blair, Joan Callahan, Doug Clancy, Giacomo DeStafano, Glenn Garvie, Bill George, Vince Marchese, R.P. McGrantham, Nancy McMullen, Peggy Norris, and E.A Smyck.

Introduction

The Gulf Coast is hammered by hurricanes, California is rocked by earthquakes, and Oklahoma is ripped apart by tornadoes. In North Jersey, we have flooding.

A natural disaster that has been exacerbated by development, flooding has become so chronic that some residents have come to expect deluged basements, evacuations, and visits from insurance adjusters every spring.

In the last five years alone, the region has endured three of the costliest floods on record, amassing an estimated $2 billion in damages. Eleven floods since 1968 have prompted federal disaster declarations, including ones in 2007 and 2010. Heavy rains in 2011 wrought more destruction, leaving some neighborhoods under chest-high water.

The problem is nothing new. The first recorded flood happened a decade before the Declaration of Independence was signed. The worst came in 1903, when the Passaic River at Little Falls crested at 17.5 feet. Even as the power of the Great Falls spurred the American Industrial Revolution, the factories and homes that sprang up along the river were often swamped by floods.

But the post–World War II housing boom in towns like Wayne, Little Falls, and Pompton Lakes, coupled with the construction of Willowbrook Mall and a vast highway system, have made the flooding worse. The winter thaw and the heavy rains of March and April have few places to go with so much asphalt and concrete covering what used to be a prehistoric lake.

In Bergen County, a deluge often forces emergency officials to bring out boats to evacuate residents of Hackensack, and neighborhoods in Saddle Brook, Lodi, and Carlstadt are often under siege by floodwaters. Tropical Storm Floyd in 1999 was especially bad, as every stream, brook, and river seemed to overflow, swamping dozens of towns in just a few short hours. A dam in Rockland County broke, sending a surge of water into Hillsdale.

Federal and state officials have spent decades searching for a solution. A special commission created by Gov. Chris Christie recommended several ways to minimize flooding in the Passaic River Basin, from removing dams to elevating homes. Some houses in floodplains are being bought out. But solutions can have unintended consequences: floodgates that helped stop flooding in Oakland may be responsible for increased flooding in Pompton Lakes.

The governor's commission made this sobering conclusion: "There is no 'silver bullet' that will solve the flooding . . . none of its recommendations can change the reality of the Passaic River Basin: Floodplains will continue to flood in this basin."

One
A History of Flooding in North Jersey

The flood of 1903 hit North Jersey between October 9 and 13 and was termed "the flood of record." It exceeded all previously recorded floods since Colonial times, including the previous flood of 1902. The flood destroyed bridges, dams, railroads, residences, and industries. It was a vicious tropical storm that caused the Passaic, Ramapo, and Pompton Rivers to swell and flood its nearby towns. On October 10, the Passaic River crested at Little Falls, measuring 17.5 feet. This is three feet more than the August 2012 Hurricane Irene, the second worst flooding disaster in North Jersey's history.

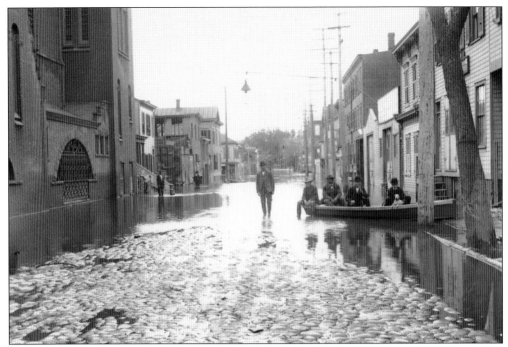

On the first day of the storm of 1903, Paterson received 11.4 inches of rain. Two days later, that number climbed to 15 inches. It took its toll on the city's thriving silk industry, injured hundreds, and left three people dead. A couple of minutes after its encounter with Paterson, the storm turned to Bergen County, wreaking more havoc across the county. (Photograph by Leonard Doremus; courtesy of the Paterson Museum.)

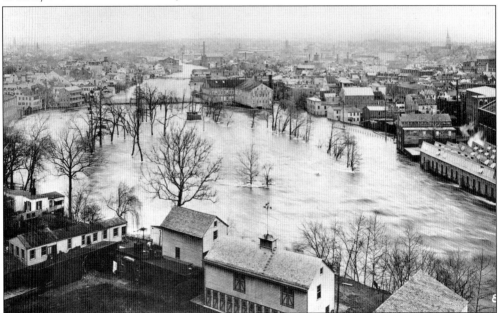

Near the Little and Great Falls, dams and highway bridges succumbed to the powerful rage of the flood. The West Street Bridge, the first bridge right below the falls, split and was carried away by strong currents, as seen in this 1903 image taken in Paterson. (Courtesy of Gene Marchese.)

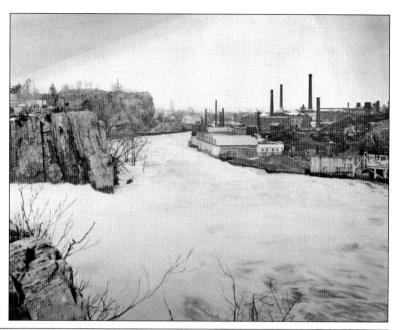

This is a 1903 aerial view of Paterson's scenic Valley of the Rocks, situated near the Great Falls. The Valley of the Rocks overlooked many of the great mill buildings that fueled the prospering city. (Courtesy of Gene Marchese.)

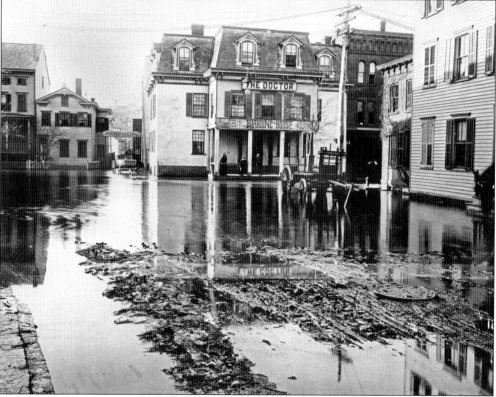

This image was also captured in Paterson in 1903. This scene at River Street near Arch Street is a common place for flooding that has endured throughout the years. The Arch Street Bridge (not shown), built only one year earlier at a cost of $34,000, collapsed during the flood. (Courtesy of Gene Marchese.)

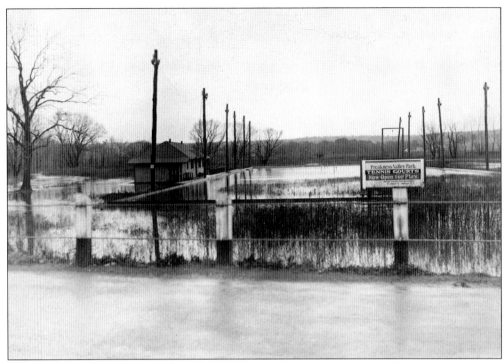

Rising waters of the Passaic River brought many homes along the banks perilously close to inundation. The county road department reported on November 10, 1932, that there were a number of road washouts, particularly in the back hill country. Shown above is the effect of the storm on the Preakness Valley Park's tennis courts near Valley Road in Wayne. Note that permits and licenses were issued on 45 Church Street in Paterson. Flooding also took place near the Dey Mansion. Constructed in 1750, the mansion once served as the headquarters for Gen. George Washington. It is known today as the "Jewel of the Passaic County Park's Department." The golf course below is located in the borough of Totowa and is one of the first 100 golf clubs to be established in the United States. (Both, courtesy of the *Paterson Evening News* archives.)

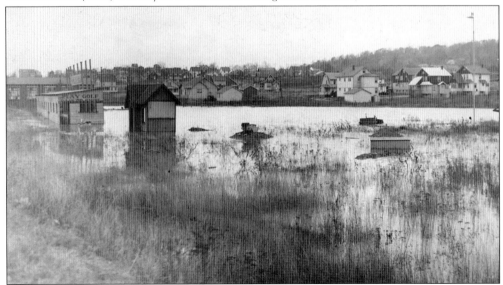

Waters from four rivers forced 1,500 families from their homes on August 24, 1933. The Ramapo River swept into the bungalow area of Oakland, while the three other major waterways in North Jersey—the Passaic, Pequannock, and Saddle Rivers—were also on the rampage, sending hundreds of residents fleeing to safety. The waters of these usually quiet rivers were churned into raging torrents as the storm that wrecked the Atlantic coast lashed at North Jersey. (Courtesy of the *Paterson Evening News* archives.)

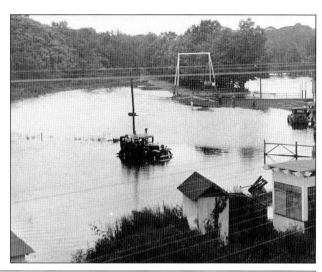

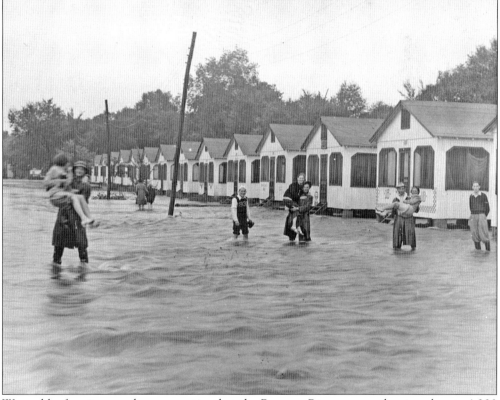

Warned by fire sirens and rescue parties that the Ramapo River was on the rise, close to 1,000 vacationers in Oakland were forced out of their beds to leave the bungalows on August 24, 1933. Rescuers are shown carrying summer residents through the swirling water to safety. The river completely inundated the summer colony section. One young girl, Sally Dorasch (not shown), who was staying alone in bungalow No. 3, was missed by the rescuers. When she awoke at 8:00 a.m., she was amazed to see the floodwaters swirling about the bungalow. She donned a pair of slacks and a shirt and walked to safety through waist-deep water. (Courtesy of the *Paterson Evening News* archives.)

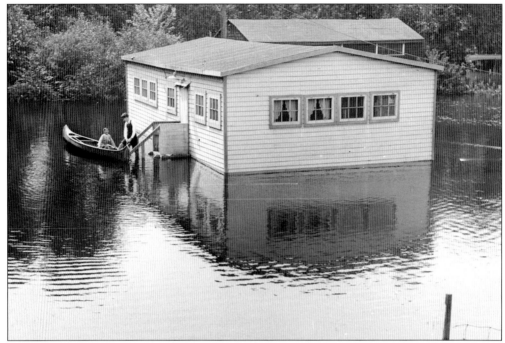

Only one month after the August flood of 1933, high waters returned on September 16 to the towns of West Paterson, Oakland, and Mountain View. The torrential storms forced many to abandon their homes. Great damage to farmers' crops was recorded in these regions, and there was fear that the bridge over the Peckman River at West Paterson might give way. Below, a family evacuates their home on September 18, 1933. (Both, courtesy of the *Paterson Evening News* archives.)

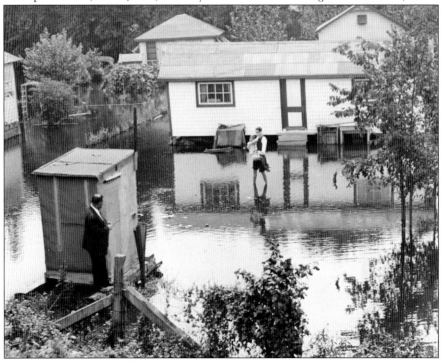

Looking east at Lakeview Avenue and East Ninth Street in Clifton in 1937, many cars are stalled under the Route 6 overpass. In 1927, the route was legislated to run from Delaware to the newly built George Washington Bridge. Today, Route 6 is part of Route 46. (Courtesy of the *Paterson Evening News* archives.)

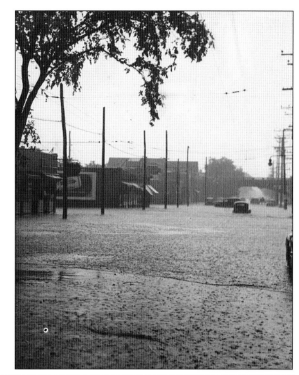

In this 1937 photograph taken at the intersection of West Broadway and River Street, floodwater reaches the doorsteps of the apartments and storefronts that line this busy street. (Courtesy of Gene Marchese.)

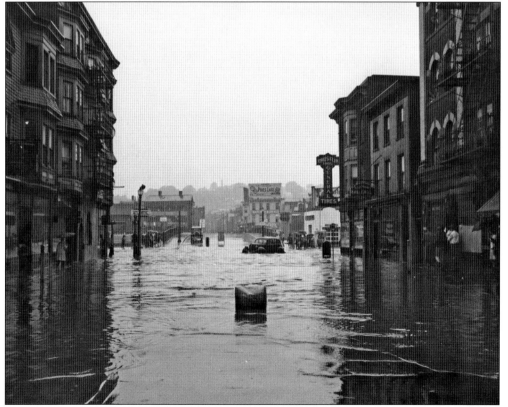

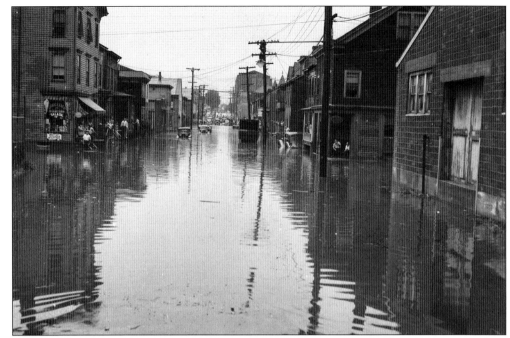

Automobiles were submerged and houses flooded during the storm that hit Paterson on July 1, 1941. Shown here is Twenty-first Avenue (formerly Clay Street) with its wide streets and numerous shops and delis. (Courtesy of the *Paterson Evening News* archives.)

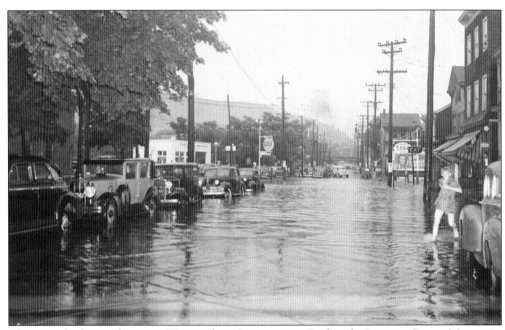

This view looks northeast on Twenty-first Avenue near Beckwith Avenue. Garret Mountain appears in the distance, as does the Erie Lackawanna rail trestle, on July 1, 1941. (Courtesy of the *Paterson Evening News* archives.)

On the morning of July 23, 1945, in Ridgewood, several inches of rain fell during the previous 12 hours. Village areas were perennially inundated after heavy rains, but never before quite like this. Mayor Frank D. Livermore of Ridgewood read a resolution launching a village-wide drainage project. He promised that such areas would receive priority attention but doubted that any system could be built that would take care of such floodwaters. (Courtesy of the *Ridgewood News* archives.)

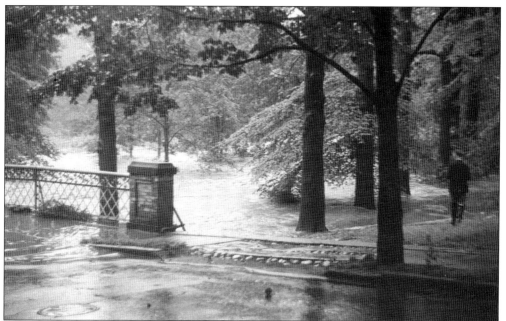

The rising waters of the Ho-Ho-Kus Brook turned land to sea and collapsed a portion of the Spring Avenue Bridge in July 1945. Sixteen Glen Rock residents and one from Ridgewood were evacuated from their homes by police and firemen and were fed and cared for by the Red Cross. (Courtesy of the *Ridgewood News* archives.)

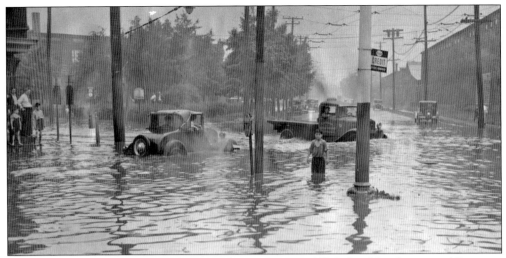

On July 20, 1945, a freak storm and torrential rains devastated Haledon, Hawthorne, and Paterson. Over a thousand workers were temporarily out of work when nearly five inches of rain raised floodwaters in Plant No. 3 of Wright Aeronautical Corporation in Fair Lawn and plants in Hawthorne. City and county road crews worked tirelessly throughout the night to clear roads of debris washed out by the storm. However, three days later, signs of flooding were still evident on the submerged streets of Paterson, as evidenced by this photograph of the crossroad of Beckwith and Twenty-first Avenues. (Courtesy of the *Paterson Evening News* archives.)

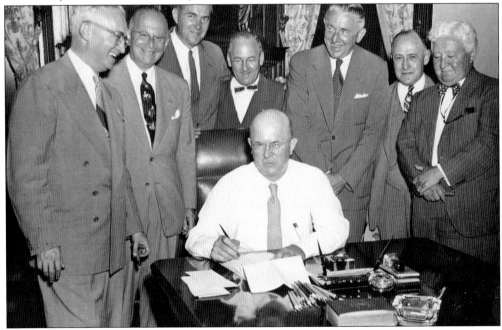

A fight of years culminated on September 9, 1948, in the signing of the Reiffin bill, which was to set the stage for future activities in Passaic Valley flood control. With Paterson flood leaders present, acting governor John M. Summerill affixed his signature to the Reiffin-enabling legislation, making it law. The action allowed the federal government's US Army engineers to recommend specific flood-control projects, such as the creation of new dams and the formation of new lakes in nearby counties. (Courtesy of the *Paterson Evening News* archives.)

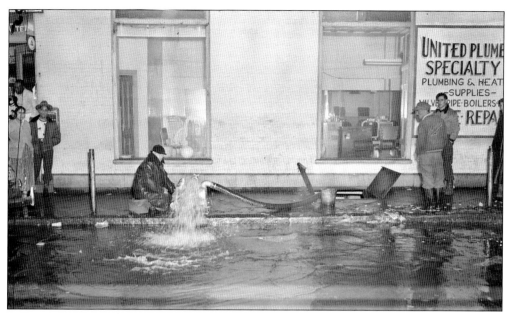

A winter storm caused extensive flooding on December 16, 1948. At United Plumbers in Mountain View, workers had to attend to their own repairs to pump out gallons of water from the store's basement. (Courtesy of the *Paterson Evening News* archives.)

On December 12, 1948, an early morning storm hit Passaic, Middlesex, Somerset, and northern Bergen County. However, the greatest damage was felt in Manville in Somerset County. Bergen and Passaic Counties were spared with very little flooding recorded. Passaic River engineers emphasized that there was no flood danger. The waters of the Ramapo, Pompton, and Pequannock Rivers showed slightly more activity, but as of 6:00 a.m. that morning, flooding impacted only 14 families in Pequannock, Wayne Township, Mountain View, and Oakland. (Courtesy of the *Paterson Evening News* archives.)

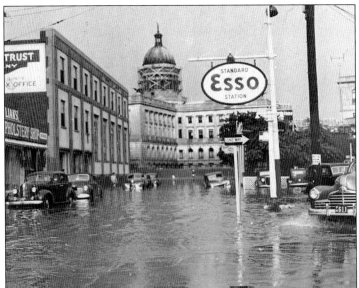

Streets over a wide area were flooded by a freak thunderstorm that struck Bergen County on July 27, 1949. This photograph shows Essex Street looking toward the courthouse on Main Street in Hackensack. Many cars stood idle until water levels began to recede the following day. (Courtesy of the *Record* archives.)

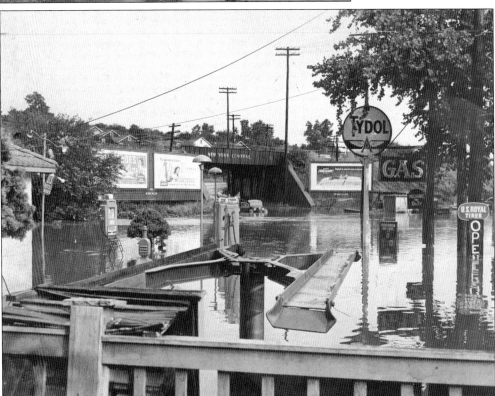

This desolate scene depicts what is usually a busy street in Hackensack. An abandoned car is stranded beneath the overhead bridge as one man runs to check the stalled car. A Tydol gas station is empty with no workers, and pumps are completely inaccessible. Cars were rerouted from this area until the floodwater subsided after July 28, 1949. Tydol Gas and its famous Flying A brand were popular throughout the 1940s; it was eventually bought out in 1956. (Courtesy of the *Record* archives.)

Many motorists were stranded while their automobiles were submerged on River Street in Hackensack. Here, several onlookers contemplate ways to recover their cars on July 27, 1949. (Courtesy of the *Record* archives.)

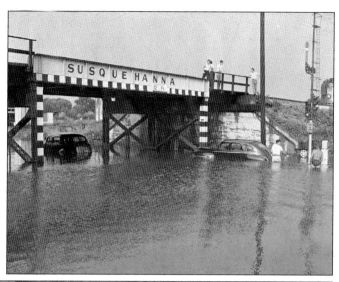

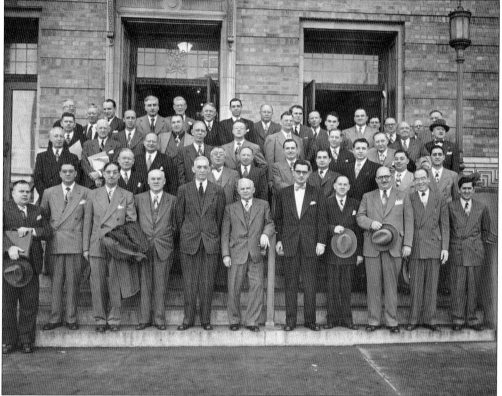

On January 25, 1950, a delegation of members from the Lower Valley met in Washington, DC, to discuss multiple proposals for plans to control flooding. The delegation, led by spokesman Russell S. Wise (first row, sixth from the left), included observers, witnesses, and county officials. Some of the witnesses used by Wise in building his case for the multipurpose reservoir plan included Sylvan Geismar, president of the Passaic Valley Flood Control Association; Mayor Michael DeVita of Paterson; Mayor Louis Bay 2nd of Hawthorne; and Richard E. Bonyun, general superintendent of the Passaic Valley Water Commission. (Courtesy of the *Paterson Evening News* archives.)

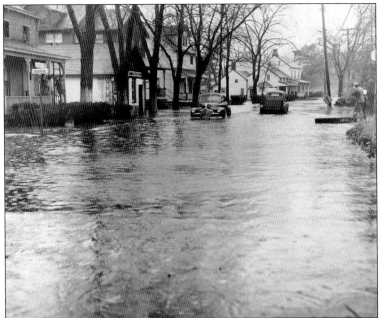

In New Milford, streets were impassable without some kind of a rowboat. Cars took their chances as they traveled up and down New Bridge Street near the corner of Steuben Avenue. On this day, November 27, 1950, New Milford experienced unusual flooding that was the result of three days of rain. (Courtesy of the *Record* archives.)

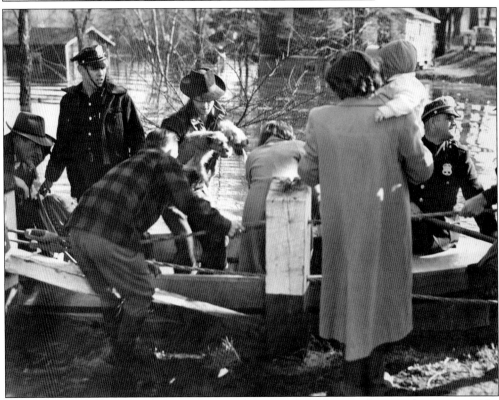

Mr. and Mrs. Phillips, their baby, and two pooches are brought to safety in a boat manned by Wayne Township police. Their situation was typical of a great many families in their area of Mountain View, which was the hardest hit in the heavy spring rain floods that rose on March 30, 1951. (Courtesy of the *Paterson Evening News* archives.)

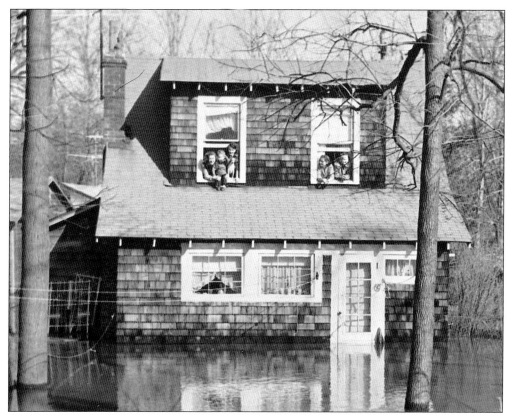

Shown in the second-floor windows of their home at 4 Island Avenue in Mountain View are four generations of the Nessman family as they await evacuation by Wayne Township police. About 1,000 families in the upper Passaic County and lower Morris County areas were evacuated. About 25 Hillcrest-area families, including Mayor DeVita's, were required to leave their homes in Paterson on the night of March 30, 1951. (Courtesy of the *Paterson Evening News* archives.)

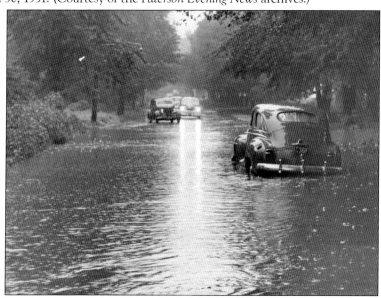

Glen Rock had a brief taste on Monday, August 12, 1951, of what the Midwest had been experiencing when heavy rains flooded this section of Prospect Street in the southern part of town. Cars had a hard time getting through, but the flood subsided quickly, leaving little damage in its wake. (Courtesy of the *Record* archives.)

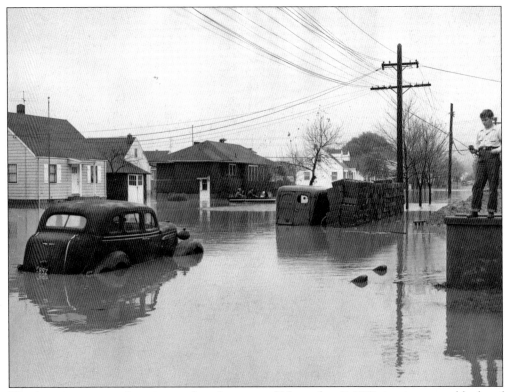

Floodwaters continued to rise on the afternoon of November 7, 1951, in six square blocks of the Hillcrest section, causing an estimated thousands of dollars worth of property damage to surrounding homes. The water backing up from a swollen Molly Ann's Brook and from leaf-jammed catch basins rose in some cellars to within six inches of the first floor. Water came up to the top of this car's fender. Traveling in a rowboat is the Kane family (center), and at the right, a boy stands on his front porch, surrounded by the floodwaters. (Courtesy of the *Paterson Evening News* archives.)

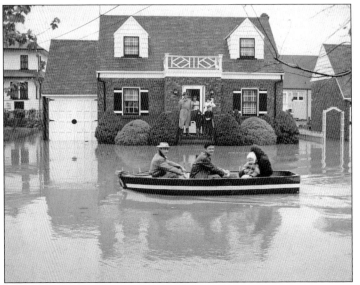

On November 7, 1951, Edward and Evelyn Kane and their three-year-old son were taken from their home in a police boat manned by a city fireman. Alderman Theodore Walters and residents at 166 Richmond Avenue look on in the background. (Courtesy of the *Paterson Evening News* archives.)

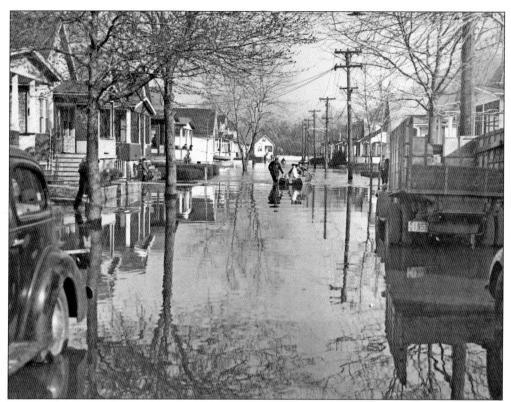

Four families on Richmond Avenue, between Chamberlain and Crosby Avenues, were evacuated to dry sections by a police boat that was brought to the flooded area earlier in the morning. The boat in this photograph was not put to use earlier because the torrential rains were being carried away rapidly enough by the brook that feeds into the Passaic River near Westwood Park. Later, however, the stream running the length of Sheridan Avenue, approximately north to south, could not absorb the heavy waters that were feeding back from the Passaic River on November 7, 1951. (Courtesy of the *Paterson Evening News* archives.)

Workers use shovels to try to move the ice from the road after a flash flood at Glen and Maple Avenues in Glen Rock on December 12, 1951. The winter storm flooded many homes in Bergen County. (Courtesy of the *Ridgewood News* archives.)

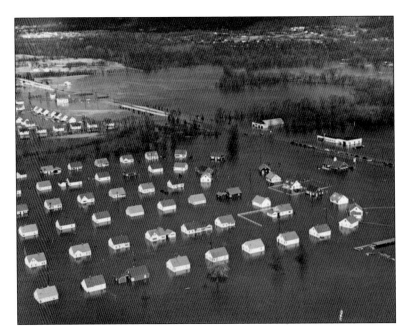

These homes along Route 23 in the Pompton Plains section of Pequannock appear more like a flotilla of small ships in a lake than the middle-class development it is. The area was covered by water in the flood of 1951. (Courtesy of the *Record* archives.)

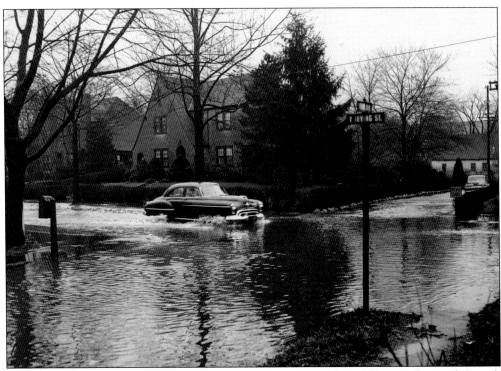

A car dares to cross flood-swollen North Irving Street on April 6, 1952, in Ridgewood. It took three days before the water began to recede. (Courtesy of the *Ridgewood News* archives.)

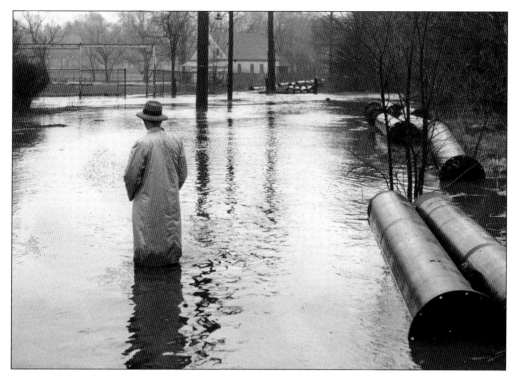

Dejection showing in his posture, an Irving Street resident in Ridgewood who has had too many flood troubles gazes down the right-of-way toward Irving Street and the high school on April 6, 1952. Water on Irving Street was more than a foot deep in some spots, making it almost impassable. The pipes seen at the right were for a sewer line under construction. (Courtesy of the *Ridgewood News* archives.)

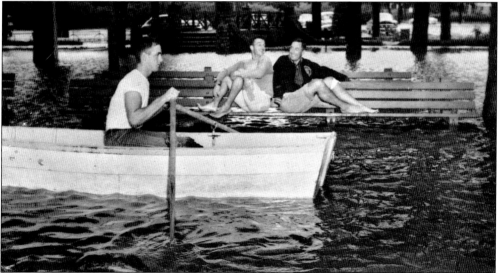

On August 18, 1955, in Ridgewood, torrential rains swept through the area in the wake of a hurricane, flooding Graydon Pool with the overflow of the Ho-Ho-Kus Brook. Officials doubted the pool would open again that season. Here, a young man navigates the floodwaters as two other men attempt to stay dry on a bench. (Courtesy of the *Ridgewood News* archives.)

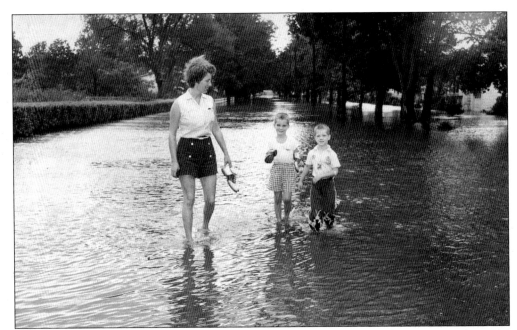

On August 19, 1955, Hurricane Diane caused major flooding in the North Jersey area. Over 200 people were evacuated in Oakland. Flooding also hit areas in Ridgewood. Taken after the storm began to quiet down, this photograph shows a mother taking her children for a leisurely walk on East Glen Avenue in Ridgewood. (Courtesy of the *Ridgewood News* archives.)

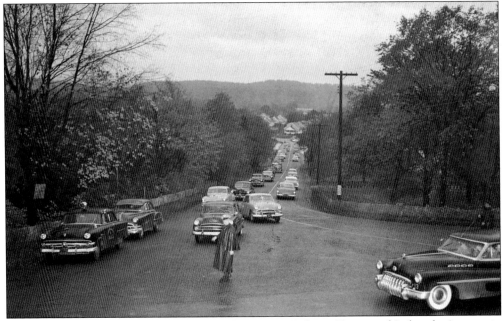

Flooding at Pompton Falls caused this traffic jam at Terhune Drive and Lakeside Avenue in Wayne Township. This congestion occurred on October 16, 1955, when traffic was rerouted off the Hamburg Turnpike, flooded at Pompton Falls. Wayne police captain Henry van Dyke directs the flow of traffic, which included hundreds of sightseers who tried to view the spectacular overflow of the dam. (Courtesy of the *Paterson Evening News* archives.)

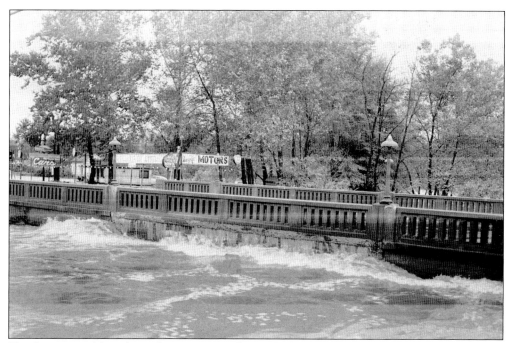

Floodwaters tumbling down the Pompton Falls smashed against the bridge on Hamburg Turnpike in Pompton Lakes, just below the falls. For the first time in history, police closed the bridge to traffic when rising waters in the surrounding area made the road impossible to cross on October 16, 1955. (Courtesy of the *Paterson Evening News* archives.)

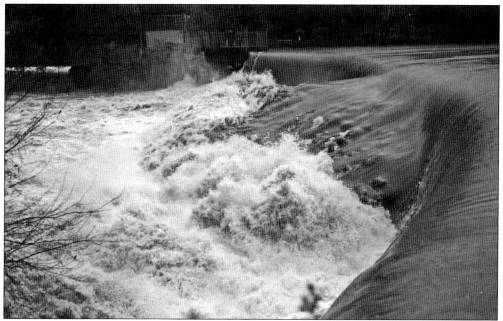

Turbulent waters at the Pompton Dam are shown as the Ramapo River shoots over the dam. Police blocked off Hamburg Turnpike in Pompton Lakes, just below the dam. The flood's death toll reached 44 in seven states across the nation and displaced over 1,500 families in northern New Jersey on October 16, 1955. (Courtesy of the *Paterson Evening News* archives.)

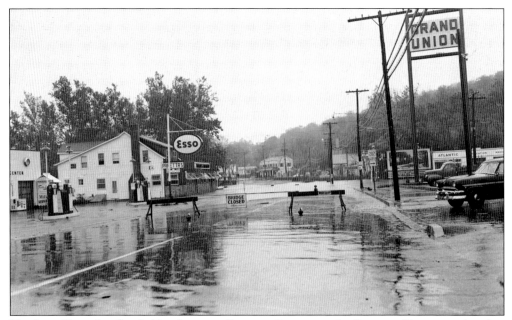

Hamburg Turnpike, flooded by the rising Ramapo River near the Pompton Dam, was closed to all traffic on October 16, 1955. Experts estimated that this was the worst flood to hit river valleys in upper Passaic and Bergen Counties and fringe communities in Morris County in 52 years. (Courtesy of the *Paterson Evening News* archives.)

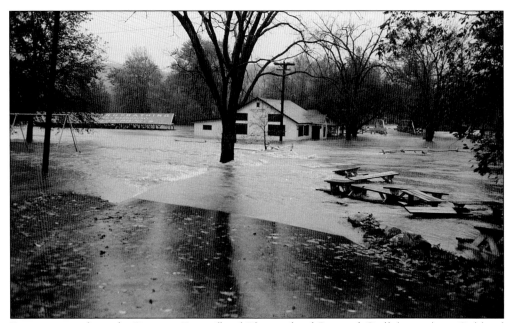

Rising waters from the Ramapo River flood Pleasureland Bar and Grill (center) on Oakland Avenue in Oakland, pictured here on October 16, 1955. The pub was part of a popular swimming camp that closed in the 1960s. (Courtesy of the *Paterson Evening News* archives.)

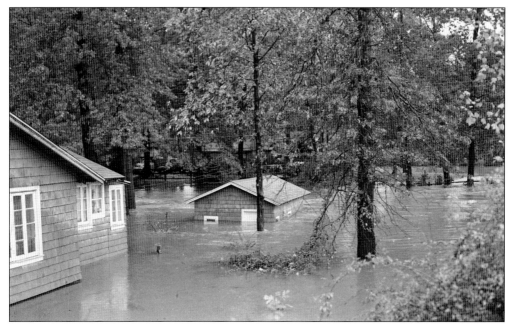

The Pequannock River, flowing wildly, created this scene at Pequannock Avenue near Route 23 in Pequannock on October 16, 1955. The small bungalow in the center of the photograph has floodwaters almost to the top of the windows. (Courtesy of the *Paterson Evening News* archives.)

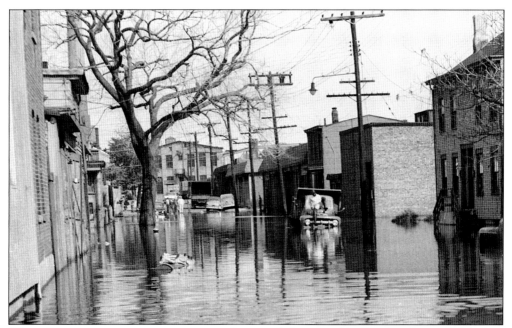

Water Street was never more appropriately named than on this October day in 1955 when floodwaters from the Passaic River rolled in. This is a view north of Arch Street near Hudson Street. Here, an unidentified man is shown atop his stalled truck waiting patiently to be towed away while other residents look on. (Courtesy of the *Paterson Evening News* archives.)

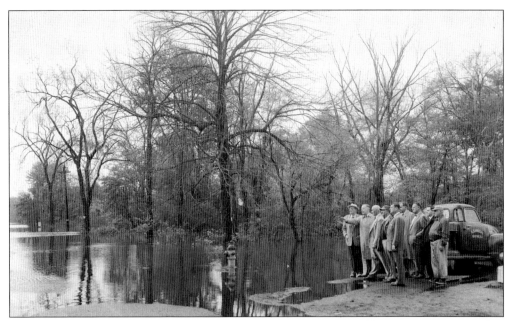

This October 16, 1955, photograph shows Congressman Gordon Canfield visiting Wayne Township and surveying flood damage. This picture was taken opposite the Mack Molding Company on Ryerson Avenue in Wayne. From this area, approximately 50 families had to be evacuated over the previous three days because their homes were surrounded by water. Pictured from left to right are (first row) Frank Cole of Wayne Township, assistant supervisor of pumping and maintenance operations, Passaic Valley Water Commission; Congressman Canfield; township committeeman Olaf Haroldson; Pasquale J. Ruggiero, president Local 230, CIO Mack Molding Company; and township committeeman Richard Caldwell; (second row) Charles Dotto, township health officer; Herbert Campbell, township engineer; Walter Kidden; and Herbert Freidormuth, executive board member of Local 230. (Courtesy of the *Paterson Evening News* archives.)

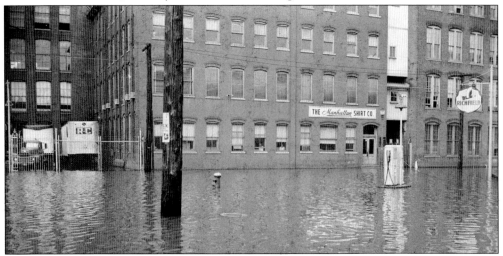

The six-story, redbrick building that housed the Manhattan Shirt Company at 237 River Street in Paterson stands with the flood-swollen Passaic River behind it and the flooded River Street area in front on October 16, 1955. The building was erected in 1909. (Courtesy of the *Paterson Evening News* archives.)

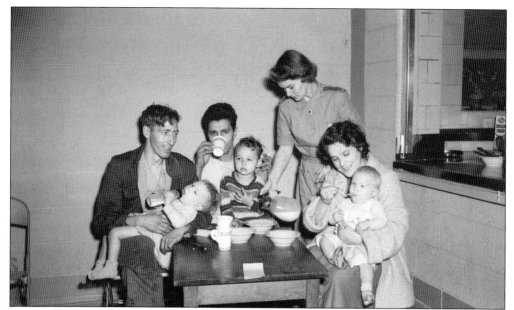

Over 1,500 families were left homeless and property damage ran to millions of dollars during the flooding of October 17, 1955. No deaths were reported in northern New Jersey; however, the rising water forced families like this one to seek refuge at Red Cross headquarters where only the bare essentials were made available to the displaced residents. (Courtesy of the *Paterson Evening News* archives.)

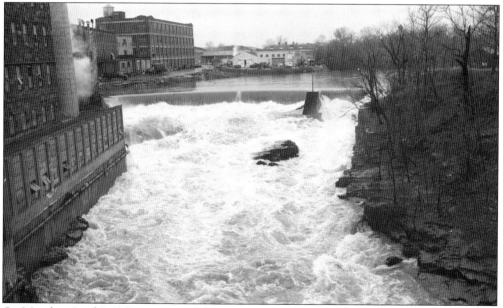

On Monday, April 7, 1958, a torrential downpour, which measured 1.70 inches at the Passaic Falls from the previous two days, brought the Passaic River to within a foot and a half of the flood stage. This brought on turbulent waters and this picturesque scene near the Passaic Valley Water Commission pumping station at Little Falls. At left is a section of the old Beattie Rug mill that operated until 1979. (Courtesy of the *Paterson Evening News* archives.)

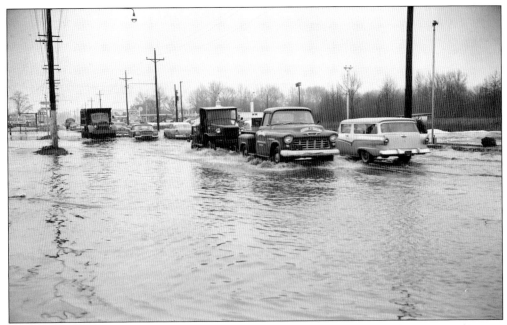

The April storm of 1958 caused the Goffle Brook, which flows south through portions of Passaic and Bergen Counties, to overflow on nearby roads, causing havoc for motorists. (Courtesy of the *Paterson Evening News* archives.)

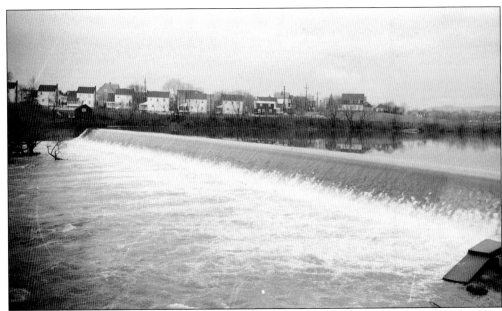

The storm on April 7, 1958, caused the swiftly moving water to cascade over the Dundee Dam at the East Paterson–Garfield line. (Courtesy of the *Paterson Evening News* archives.)

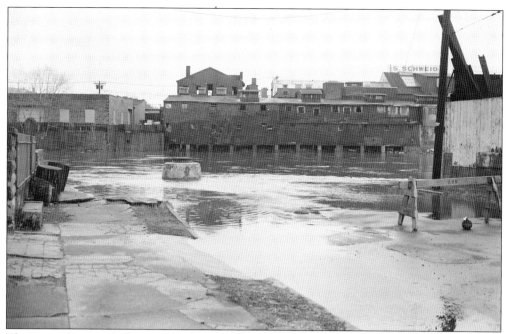

The Passaic River spilled over its banks at Holsman Street in Paterson shortly before noon on April 5, 1960, as rain fell for the third day in a row. Rivers were also observed rising over their banks in Wayne Township, Pompton Lakes, and Pequannock. This photograph shows river water running into Holsman Street and initiating the devastating flood conditions. This vulnerable street is the lowest spot along the river in Paterson. (Courtesy of the *Paterson Evening News* archives.)

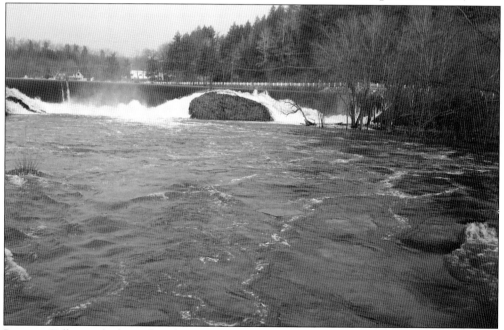

Pompton Falls is pushed to its limit by Ramapo River floodwaters, as water cascades into the Pompton River at Route 202 and Hamburg Turnpike. Sections of Wayne Township and Pompton Lakes were flooded on April 5, 1960, as a result. (Courtesy of the *Paterson Evening News* archives.)

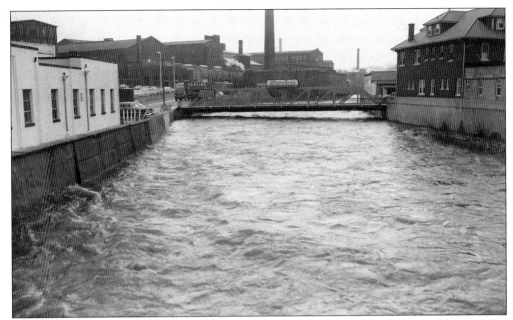

The Passaic River roars through and almost laps at the deck of the Mulberry Street Island Market Bridge in downtown Paterson. This photograph was taken in April 1960 from the West Broadway Bridge. The river and others in the area spilled over their banks for the first time in several years. (Courtesy of the *Paterson Evening News* archives.)

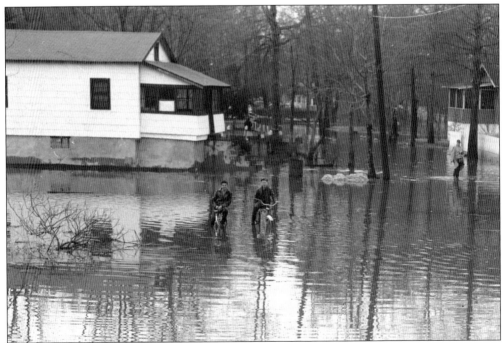

Standing water on Fayette Avenue in Mountain View does not daunt these two youths on bicycles. The low-lying area is usually the first in the county to become flooded. This image was captured on April 5, 1960. (Courtesy of the *Paterson Evening News* archives.)

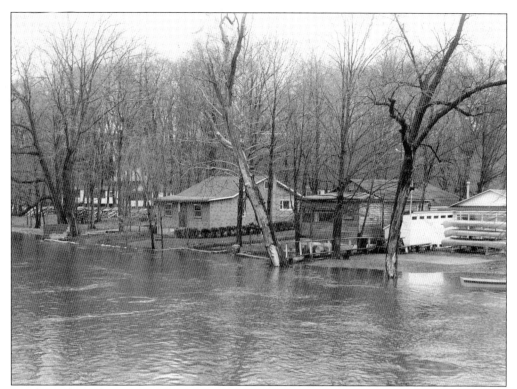

Residents along the Ramapo River in Oakland found water in their backyards on April 6, 1960, when heavy rains sent the river 10 inches over the flood level—three feet above normal. This picture was taken from the West Oakland Avenue Bridge after the river started to drop and was down to three feet, four inches above normal. Water spilled over into the streets in the island areas and River Road. (Courtesy of the *Record* archives.)

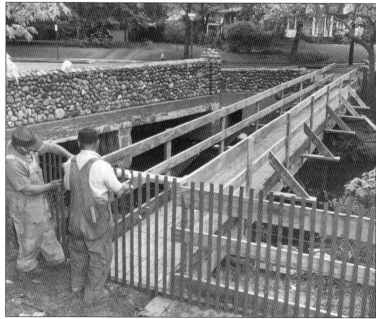

On May 20, 1961, workmen from Frapaul Construction Co. of Hackensack began construction of the new Irving Street Bridge in Ridgewood. Frapaul was under a $69,791 contract from the county to build the bridge, designed to alleviate the village's flood problem. (Courtesy of the *Record* archives.)

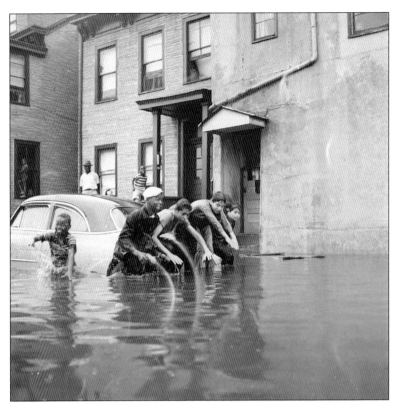

Many residents faced with flooded cellars, stranded cars, no electricity, and high temperatures found some refuge in the streets as a means to pass time. Children in Paterson played in waist-high water in the streets to make the best of a bad situation on July 20, 1961. (Courtesy of the *Paterson Evening News* archives.)

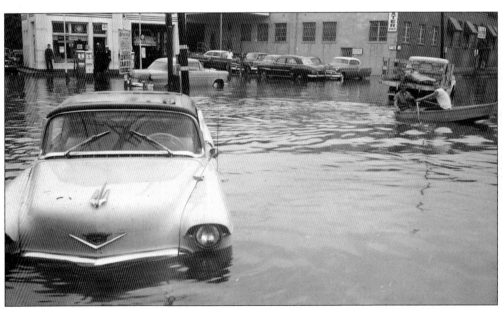

Torrential rains dropped in on Paterson on July 20, 1961, causing widespread floods. Many motorists were marooned in their cars awaiting dispatched police to come to the scene. Rowboats were used by firemen to take stranded victims to dry land. (Courtesy of the *Paterson Evening News* archives.)

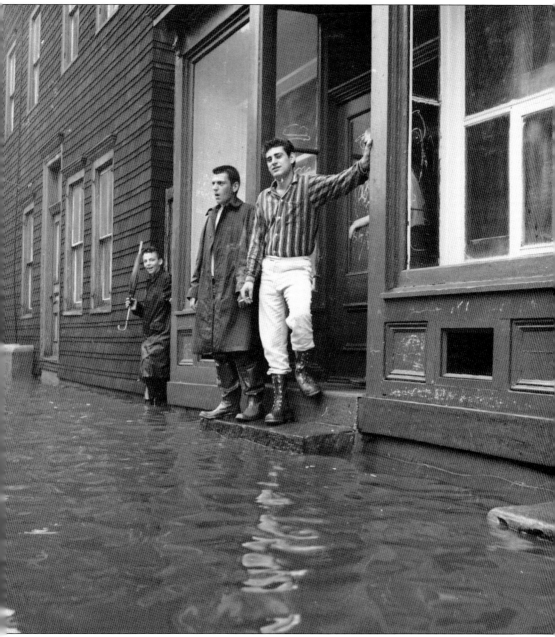

On the morning of July 20, 1961, Paterson residents looked on to gauge what the Public Works Department called "the worst storm in years." Equipped with boots, raincoats, and umbrellas, these locals seek shelter on nearby doorsteps. Not far from this scene, a woman and her child were marooned in a car at the intersection of Grand Street and Railroad Avenue. The fire department dispatched its rescue truck to the scene. (Courtesy of the *Paterson Evening News* archives.)

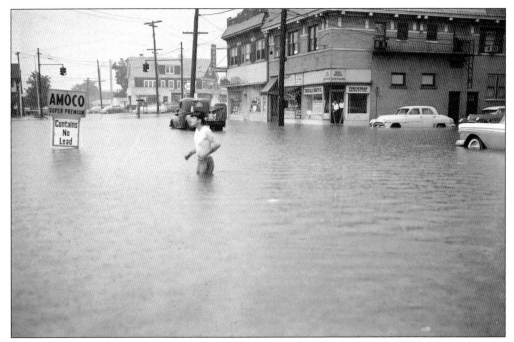

While many people stood in dry areas of their homes and nearby stores, this hardy soul wades through water on Twenty-first Avenue and Market Street in Paterson on July 20, 1961, to get to his destination. Reports indicated that the heaviest flooding in Paterson was at a point where Market Street, Twenty-first Avenue, and East Thirtieth Street meet. (Courtesy of the *Paterson Evening News* archives.)

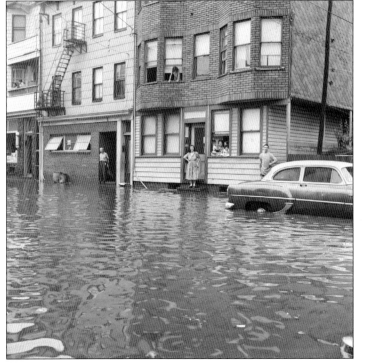

Between 9:45 and 11:00 in the morning of July 20, 1961, approximately 2.65 inches of rain fell on Paterson. People took shelter in homes and stores along the area. The flooding was up against the entrance of the doors. "I have never seen anything like this," said Herman Silver, who operated a liquor store at 795 Market Street. "This is the worst yet," he proclaimed. (Courtesy of the *Paterson Evening News* archives.)

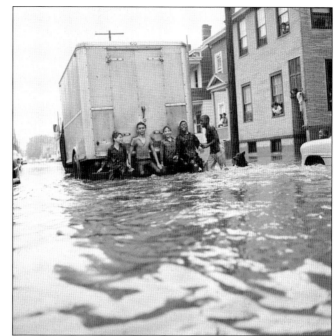

By the late afternoon, the rain had died down, but the weather was warm and humid. Temperatures reached the upper 80s and several residents took to the streets to cool off on July 20, 1961. (Both, courtesy of the *Paterson Evening News* archives.)

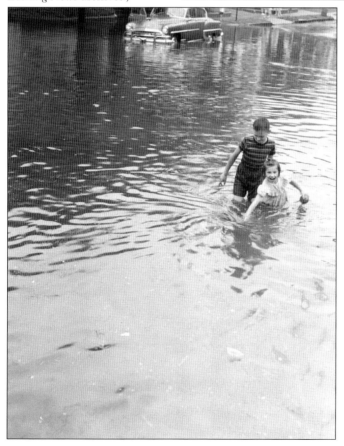

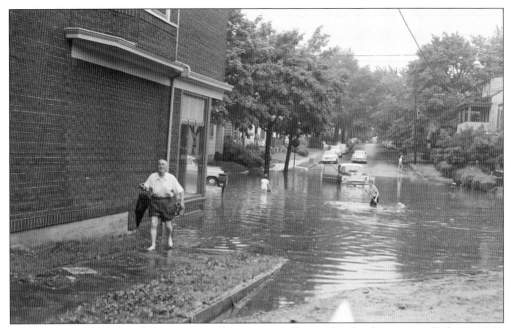

Hyman Baron (left) found that an umbrella was not sufficient for the downpour of July 20, 1961. He took off his shoes, rolled up his pants, and waded through the flooded intersection at East Twenty-fifth Street and Eleventh Avenue to get to his destination in Paterson. (Courtesy of the *Paterson Evening News* archives.)

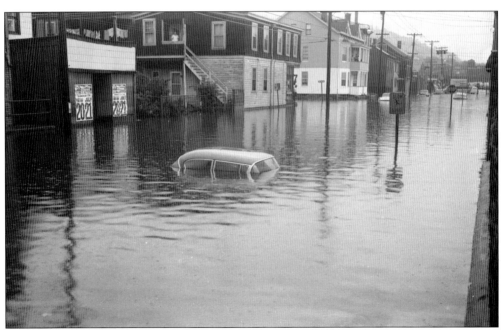

Almost totally submerged, this car is evidence of the unusually heavy flood at Twentieth Avenue between Market Street and River Street in Paterson. This photograph was taken at the height of the rainstorm on July 20, 1961. (Courtesy of the *Paterson Evening News* archives.)

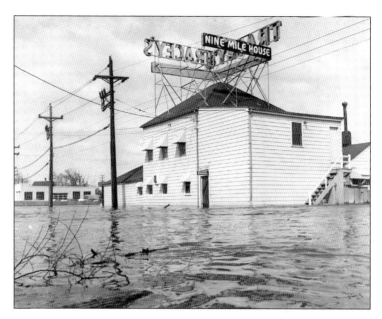

Tracey's Nine Mile House at the foot of Bergen Turnpike in Little Ferry presented this scene on March 8, 1962. Water surged into the old restaurant, located a short distance from the Hackensack River. Water in Little Ferry caused officials to evacuate some families, close the schools, and call out police, fire and Department of Public Works forces when the mayor declared an emergency. (Courtesy of the *Record* archives.)

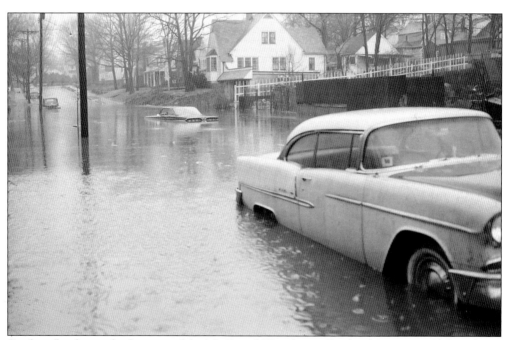

Swirling floodwaters backing out of the MacDonald Brook onto Rowland Avenue in Clifton almost claimed the life of Florence Schwartz of 38 Woodward Avenue. This photograph shows Rowland Avenue looking south from Huron Avenue, near the Passaic city line. Three cars were stranded; however, Schwartz was rescued from her car (shown in center) by a policeman and a resident in a rowboat. Several residents trapped in their homes were evacuated by police on March 8, 1962. (Courtesy of the *Morning Call* archives.)

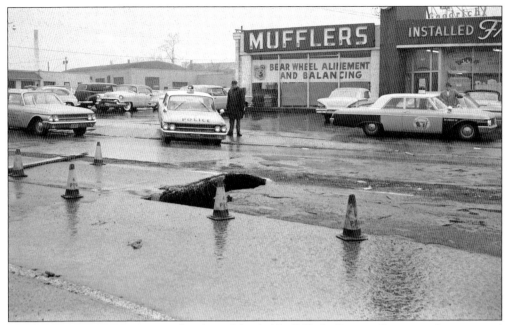

Northern New Jersey saw many floods on March 13, 1962. In Bergen County, police reported flooding conditions in the northbound lane of Route 17 in Paramus. Route 46 traffic circles in Lodi and Little Ferry were flooded. In Passaic County, roads collapsed, and others were clogged up. A gaping hole on Market Street near McLean Boulevard was caused when a sewer collapsed in Paterson, pictured here. The mayor ordered traffic diverted in the area where work on a new sewer was scheduled to get under way in June of that year. (Courtesy of the *Morning Call* archives.)

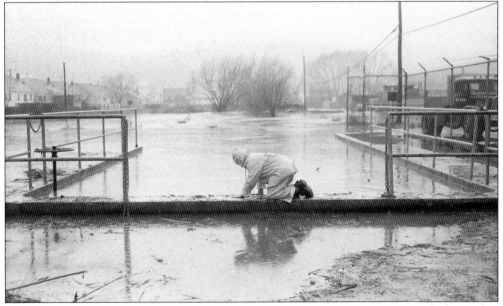

In this view looking south, the debris-clogged entrance to the Hillcrest storm relief tunnel at Crosby and Rossiter Avenues is inspected by a board of works employee. A large crane owned by V. Ottila & Sons was called to the scene later to help clear debris from a clogged screen covering the tunnel entrance on March 13, 1962. (Courtesy of the *Paterson Evening News* archives.)

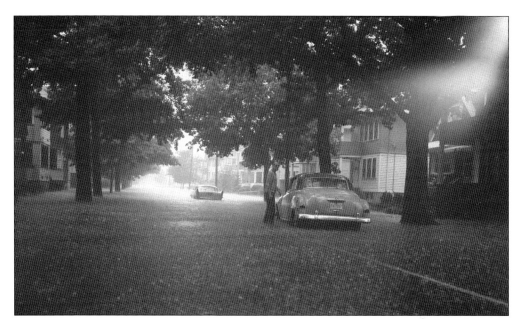

On August 9, 1962, the rain returned, tying up motorists, flooding streets and swamping underpasses. Clifton was hit hard, leaving several cars stranded. Tornado-like winds were reported in Paramus and other sections of Bergen County. The area that looked like a miniature lake (above) stranded this one man; however, with some creativity, some residents found ways to become mobile (right). The man in the rowboat is shown at the scene on Trenton Avenue, off Market Street, at the height of the morning's deluge. (Both, courtesy of the *Paterson Evening News* archives.)

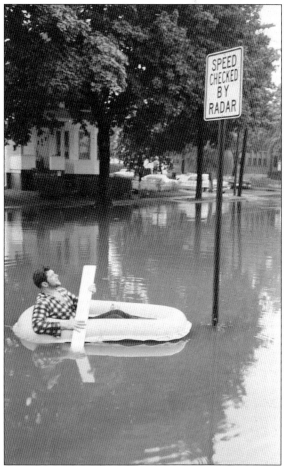

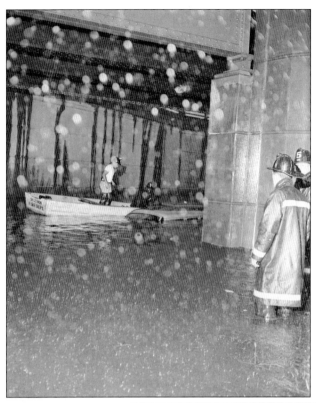

A blustery nor'easter drenched the North Jersey area on September 21, 1966, with a record rainfall that caused numerous floods, traffic snarls, and construction delays. Rain flooded the basement of Manchester High School in Haledon and the Van Raalte Knitting Mill factory in Boonton. In Wayne, flash flooding affected Route 23 at Packanack Lake Road. Traffic was rerouted through the driveway of Nagel's Candy Shop. More flooding occurred on French Hill Road at Little Pond Road. In Fair Lawn, the most serious flooding was at Berkshire Road near Warren Point School. In Paterson, a motorist under water was rescued from Route 80 underpass (left), and the flood erupts from a manhole on Twenty-first Avenue (below). (Both, courtesy of the *Morning Call* archives.)

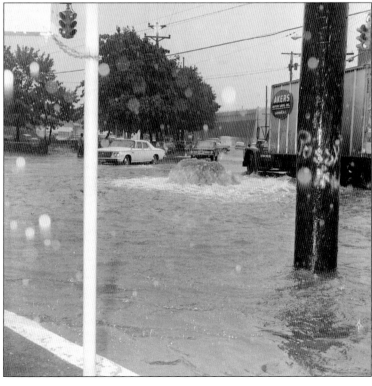

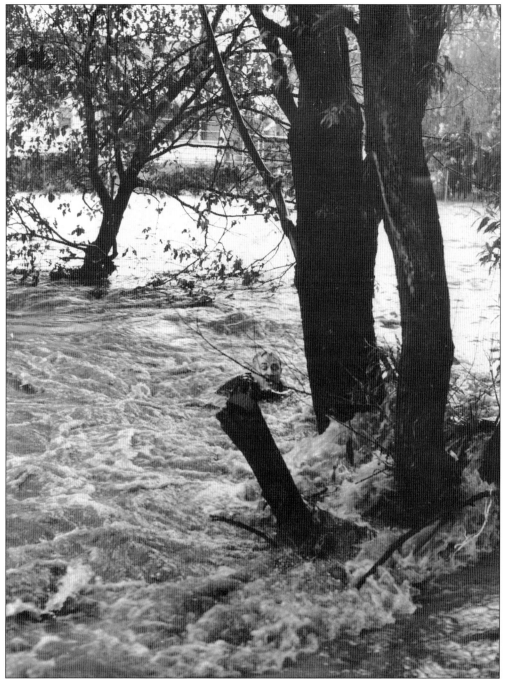
Paterson assistant fire chief William J. Comer, trying to swim the raging Molly Ann's Brook to rescue a boy stranded in a tree, almost drowned during the attempt on May 30, 1968. Later, Comer received a commendation ribbon from the fire and police board for his heroic effort. (Courtesy of the *Morning Call* archives.)

As the flooding from May carried into June, the Passaic River started to recede, but its deadly currents were still taking its toll. Police warned flood-stricken municipalities to do as little traveling as possible; however, the death rate from the flood rose to six and included an 11-year-old Haskell boy who was swept away by the roaring Haskell River when he rode his bike too close to floodwaters. On June 1, two boys from Pompton Lakes launched a boat on the Pompton River but soon capsized and were holding on to a tree for dear life. Soon, a canoe with four other boys picked them up, but the craft was pulled over the Guard Dam by the strong currents. Both boys disappeared that day, and a search party was organized by the Wayne, Pompton, and Pequannock rescue squads. By 10:00 p.m., the search was called off. Seen here are a news clipping of the missing children from the front page of the *Paterson Evening News* (left) and Ronnie Wescott and John DeLoot of the Wayne Rescue Squad searching the Pompton River for the two boys to no avail (below). (Both, courtesy of the *Paterson Evening News* archives.)

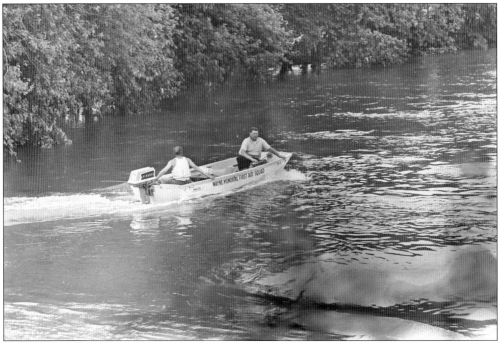

Dietch's Kiddie Zoo, located on Saddle River Road in Fair Lawn and about two miles from the Garden State Parkway, had one of the most extensive collections of wild and domestic animals. The zoo was a popular attraction that included numerous carnival rides and concessions. In late May 1968, as heavy rains came in, zoo workers were forced to evacuate many of the valuable animals. Some reports indicate that the zoo closed down later that year. In addition, hundreds of West Bergen–area families were instructed to vacate their homes. (Courtesy of the *Morning Call* archives.)

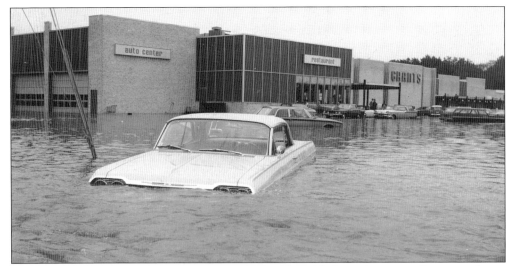

The popular Plains Plaza shopping center on Route 23 and Jackson Avenue in Pequannock was inundated by heavy rains as rising waters flooded basements and first floors. Many cars stood stranded near Grant's Department Store on May 30, 1968. (Courtesy of the *Morning Call* archives.)

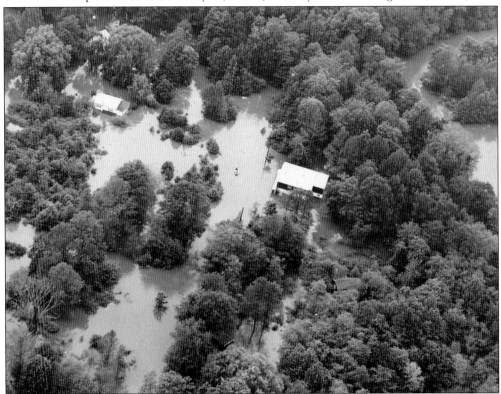

Many proposals were made for flood-control plans for Lincoln Park, but none had much effect as of June 1, 1968. The town, which usually encounters flooding during the month of May, suffered a rapid surge of water flow that caused much damage and continued for days unabated. This aerial view shows flooding so severe that rescue boats had to evacuate many families. (Courtesy of the *Morning Call* archives.)

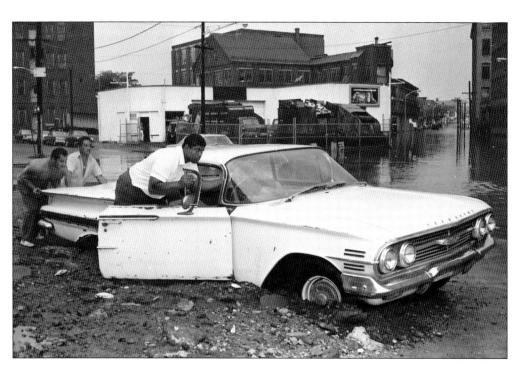

Paterson's downtown streets felt the brunt of the heavy downpour in July 1969. Water covered busy sidewalks, stranded many pedestrians, reached storefronts, and flooded cars and trucks. The intensity of the rain-damaged roads caused cars to get stuck in two-foot ditches. Motorists were forced to steer their vehicles out of trenches (above). (Both, courtesy of the *Morning Call* archives.)

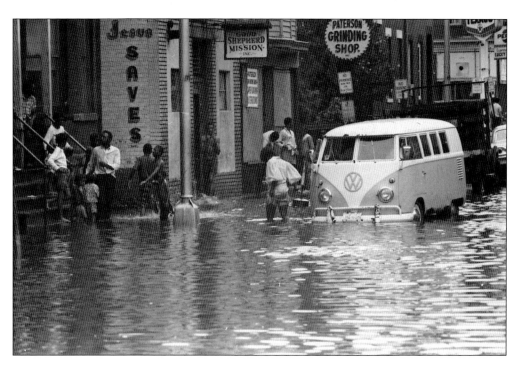

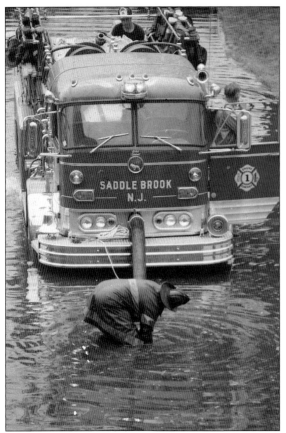

Heavy rain arrived again on August 16, 1969. In Wayne, 1.6 inches flooded Fayette Avenue. The Hamburg Turnpike was also flooded near the Preakness shopping center. In Saddle Brook, police claimed that "the whole town was flooded." In Glen Rock, two automobiles were trapped in flooded streets. One of the motorists was Marjorie Casey of Dumont, who told police her brakes gave away and the car rolled under the underpass. She abandoned her vehicle and called for help. Minutes later, the car was completely submerged. There was an electrical fire at Saddle Brook General Hospital, which is seen below. All fire department personnel (some are seen at left) rushed to the scene at 6:00 p.m. and stayed there till 10:30 p.m. Patients were not evacuated. (Courtesy of the *Paterson Evening News* archives.)

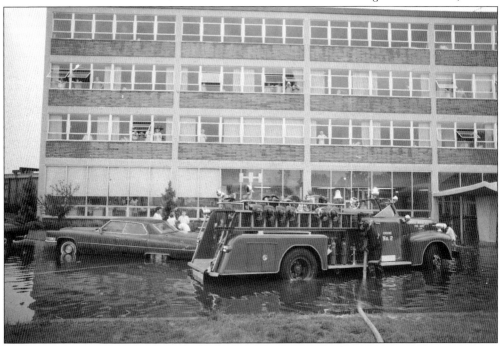

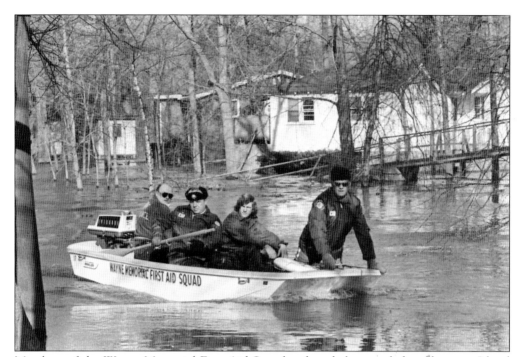

Members of the Wayne Memorial First Aid Squad rush to help stranded residents on Island Street near Route 23 and the Fayette Avenue Park. Island Street, as well as many areas in Wayne, experienced severe flooding in February 1970 due to the overflow from the Pompton River. (Courtesy of the *Paterson Evening News* archives.)

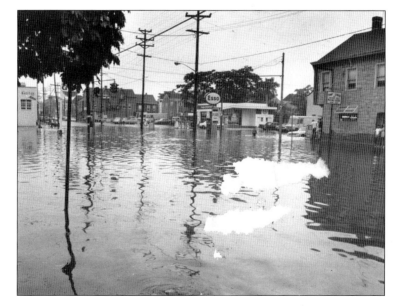

The federal government stated it wished to discourage development in areas prone to flooding, such as the section of Paterson shown in this 1970 photograph. (Photograph by Dan Oliver; courtesy of the *Record* archives)

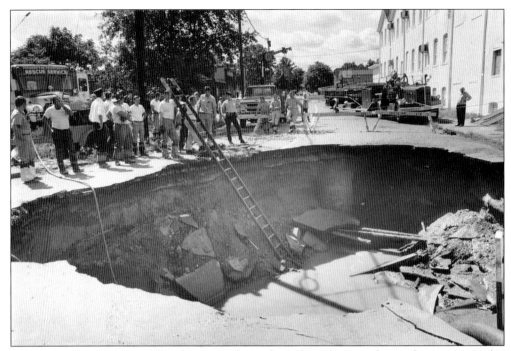

A Fair Lawn man in his Cadillac disappeared into this hole 10 feet past the Morlot Avenue Bridge in 1971. The 12-foot-deep opening was the result of flooding caused by the overflowing Passaic River. (Courtesy of the *Record* archives.)

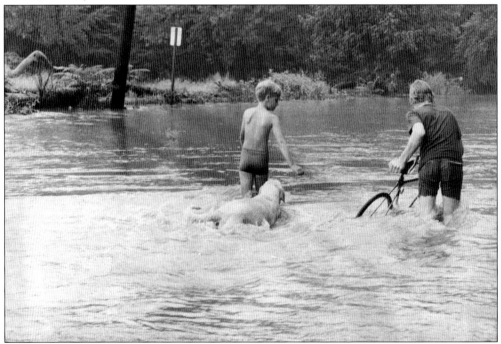

A flooded Grove Street in Ridgewood on September 12, 1971, offered a play area for two boys and a dog. Many trees toppled on nearby streets, knocking down some power lines. (Courtesy of the *Ridgewood News* archives.)

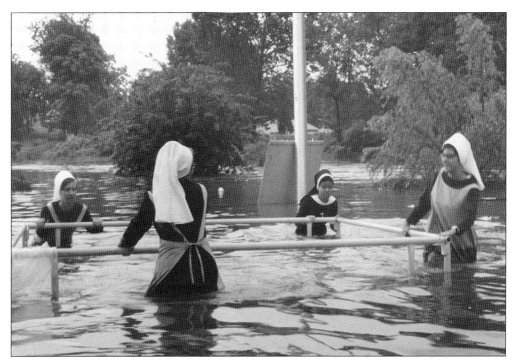

In Lodi, a nun and novices from Felician College begin the process of cleaning up their campus on Main Street after heavy rains fell during their school event on September 12, 1971. The campus was inundated by an overflow from the nearby Saddle River. (Courtesy of the *Record* archives.)

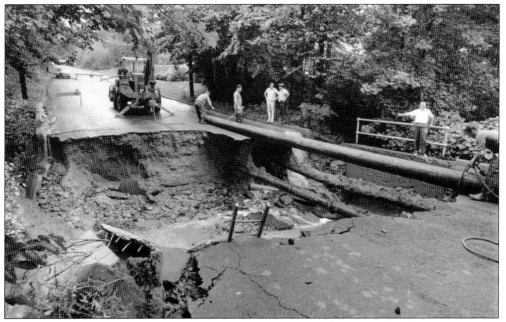

In Ho-Ho-Kus, the heavy rains and flooding washed out the Mill Street Bridge, leaving gas, water, and sewer lines exposed. Workers lashed mains to telephone poles, but a broken sewer line dumped raw sewage into the Saddle River. It took several days to rebuild the bridge, as evidenced by this September 12, 1971 image. (Photograph by Ed Hill; courtesy of the *Record* archives.)

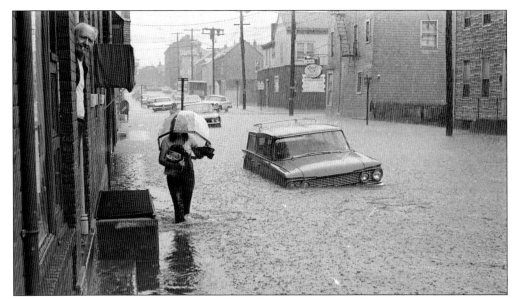

During the storm of June 1, 1972, this young lady keeps her powder dry and her feet wet while she wades, boots in hand, along flooded Cedar Street during the day's violent downpour. Two inches of rain fell between 1:00 p.m. and 2:30 p.m. A stalled car, submerged to its lights, indicates the depth of the water flooding the area near the Cedar and Summer Streets intersection in Paterson. (Courtesy of the *Paterson Evening News* archives.)

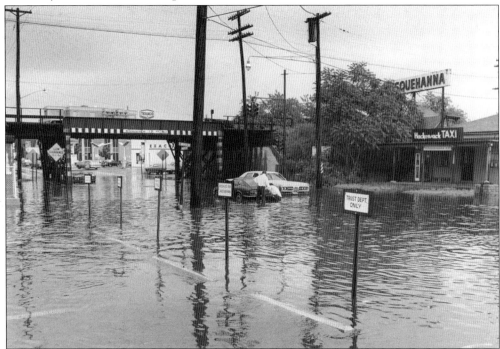

Motorists wade in water swirling around their stalled vehicle on River Street in Hackensack on June 1, 1972. Heavy rains inundated many low-lying areas in the metropolitan area. Meanwhile, the city worked on plans to rehabilitate its drainage system. (Photograph by Dan Oliver; courtesy of the *Record* archives.)

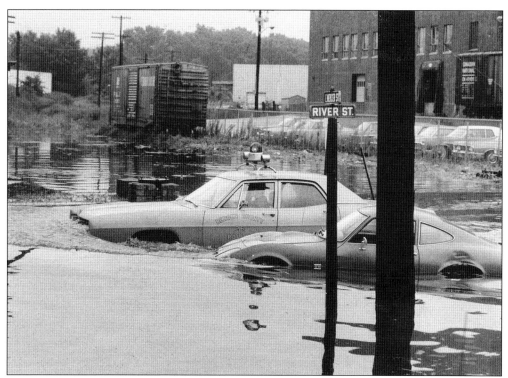

This area of River Street in Hackensack constantly receives water overflow from the nearby Hackensack River. On August 3, 1973, flooding conditions worsened, prompting officials to seek federal funding to alleviate future scenarios. Bergen County police attempt to go through high waters on the corner of River and East Mercer Streets. (Photograph by Robert Brush; courtesy of the *Record* archives.)

On August 4, 1973, Wayne experienced the heaviest downpour since 1941. The streets in this area turned into waterways, and powerboats and rowboats scoured the area near the Willowbrook Mall to help evacuate residents along the Passaic River. On that day, the back entrance to the mall at Route 23, near Route 46, was closed. (Courtesy of the *Record* archives.)

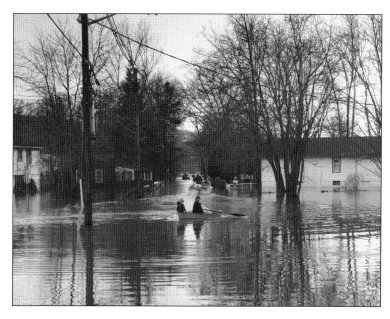

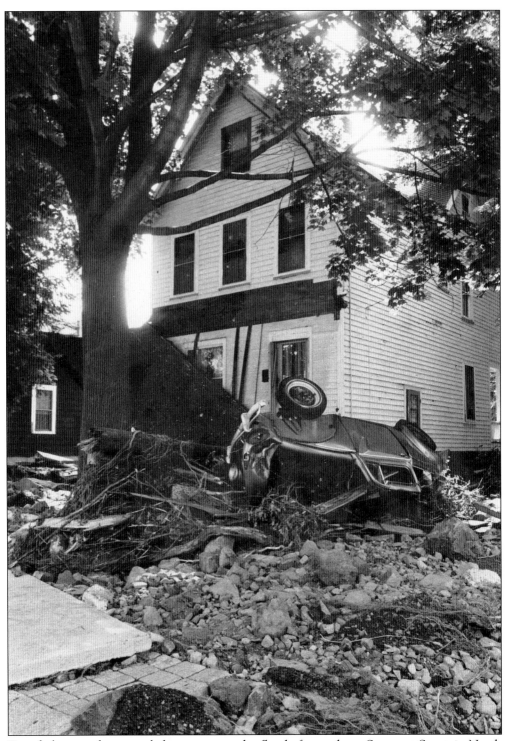

Record photographers traveled out to cover the flood aftermath on Somerset Street in North Plainfield on August 5, 1973. Flooding caused severe damage to this car and house. (Photograph by Ed Hill; courtesy of the *Record* archives.)

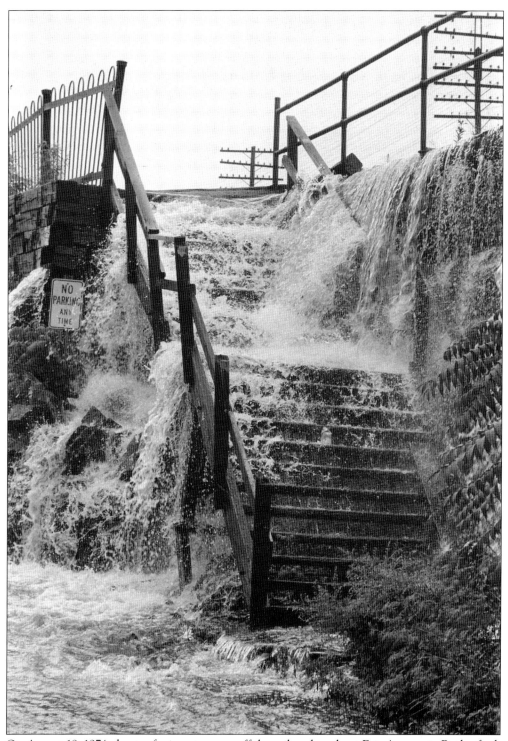

On August 18, 1974, sheets of rainwater pour off the railroad tracks at Erie Avenue in Rutherford. Thundershowers dumped a record 2.5 inches of rain in the metropolitan area, bringing power failures, traffic delays, and accidents. (Photograph by Gordon Corbett; courtesy of the *Record* archives.)

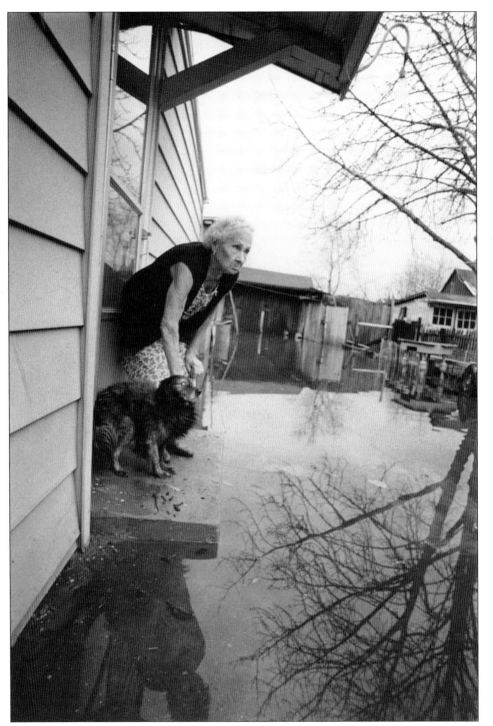
Annie Schwartz and her dog stand on their doorstep looking over the floodwater damage in their Hackensack neighborhood. On December 3, 1974, most of the houses on Water Street were inundated by the storm and many families had to evacuate. (Photograph by Peter Karas; courtesy of the *Record* archives.)

Crossing the roadway to Ridgewood's Graydon Pool proves no small obstacle to Ho-Ho-Kus youngster Bruce Enger. He was only one of many persons who faced delays in reaching their destinations when heavy rains fell over the North Jersey area and caused serious flooding on July 17, 1975. (Courtesy of the *Ridgewood News* archives.)

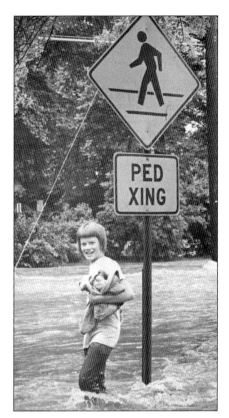

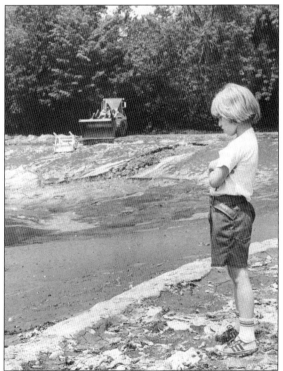

Summer days drag on for Michael Rizzo of Ridgewood as he waits for flood-drenched Graydon Pool to reopen on July 20, 1975. Graydon is a natural pool that was established in 1929. (Courtesy of the *Ridgewood News* archives.)

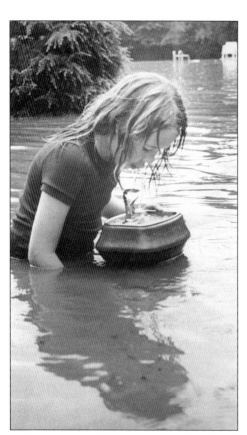

Water, water everywhere made Margaret Humrich of Ridgewood thirsty enough to search out a fountain in the midst of Graydon Pool. Rains soaked all of New Jersey in July 1975. (Courtesy of the *Ridgewood News* archives.)

A Bergen County public works crew starts repairs on the East Ridgewood Avenue Bridge on July 16, 1975. (Photograph by Dan Oliver; courtesy of the *Record* archives.)

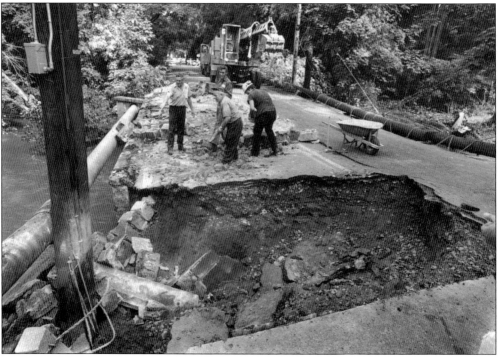

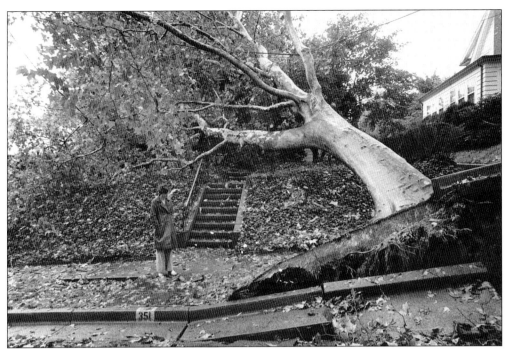

On August 10, 1976, Mrs. Anthony Benigno of Hamilton Place in Hackensack inspects a Sycamore tree that crashed through her bedroom during the devastation of Hurricane Belle. (Courtesy of the *Record* archives.)

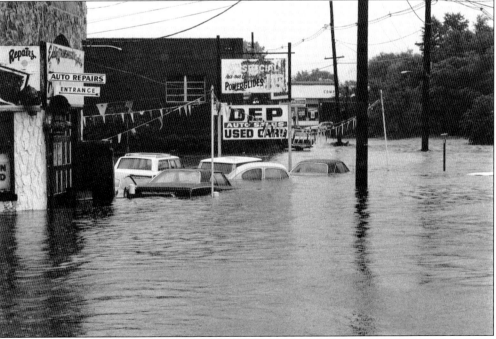

Flood warnings turned to reality in Hawthorne, as seen on the corner of North Eighth Street and Goffle Road on July 15, 1975. Waters rose six feet and covered several cars at a local used car dealership. (Photograph by Dan Oliver; courtesy of the *Record* archives.)

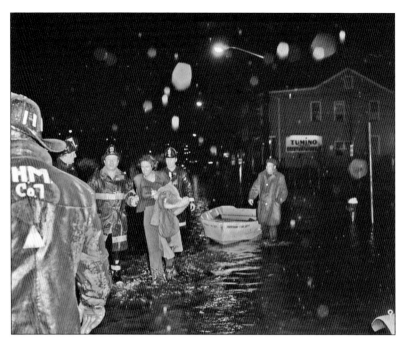

Paterson flood victims are evacuated by the fire department at Summer Street and Twenty-first Avenue near the Route 80 overpass on February 24, 1977. (Courtesy of the *Paterson Evening News* archives.)

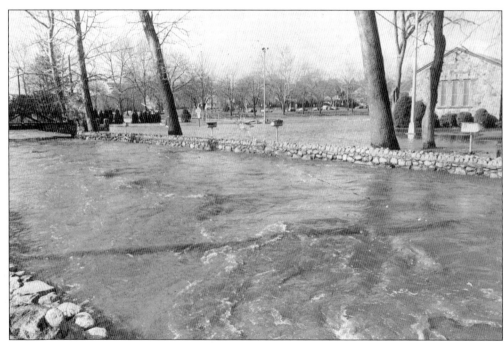

Swirling waters of Ho-Ho-Kus Brook and a flooded Graydon Pool in Ridgewood were evidence of the rain that came on February 27, 1977, which caused flooding throughout the area. Motorists were stranded on flooded streets at the height of the downpour. (Courtesy of the *Ridgewood News* archives.)

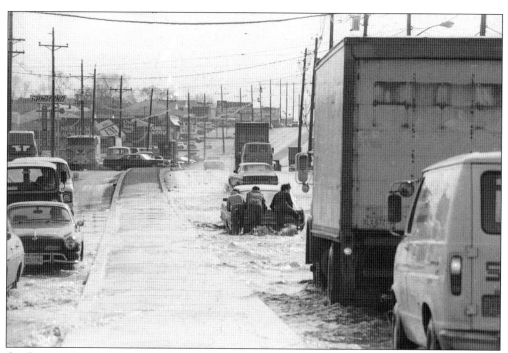

On Route 46, rising water stalls a car making its way up the road on February 25, 1977. Men struggle to get the car to a drier section of the road. Delays on the road continued for several days as the water took two full days to recede. (Courtesy of the *Paterson Evening News* archives.)

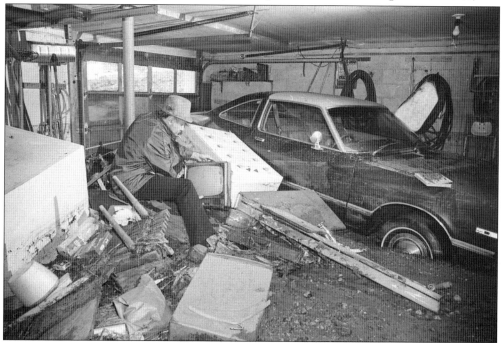

This man's garage was totally inundated on Page Drive in Oakland on February 25, 1977. He attempts to salvage his belongings, including his car, a television, and some furniture. (Courtesy of the *Paterson Evening News* archives.)

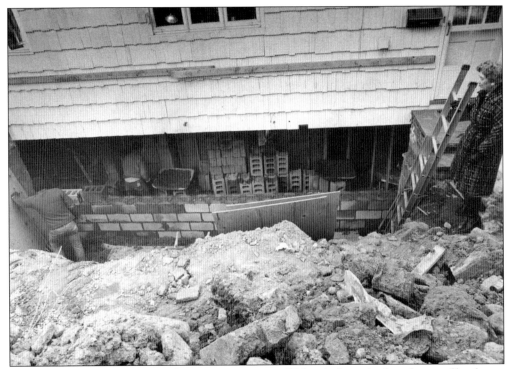

Ruth Fort (right) watches as workmen repair a gaping 25-foot hole in the foundation of her home at 303 Lakeside Drive in Ramsey. The damage was caused by rushing floodwaters. Fort said that even though she had drains around the house, the water rushed downhill from Franklin Turnpike and struck with the force of Niagara Falls, February 2, 1978. (Courtesy of the *Ridgewood News* archives.)

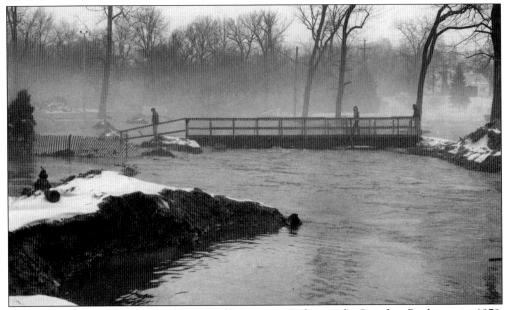

High waters of the Ho-Ho-Kus Brook spill over into Ridgewood's Graydon Pool area in 1979. (Photograph by Paul Brown; courtesy of the *Record* archives.)

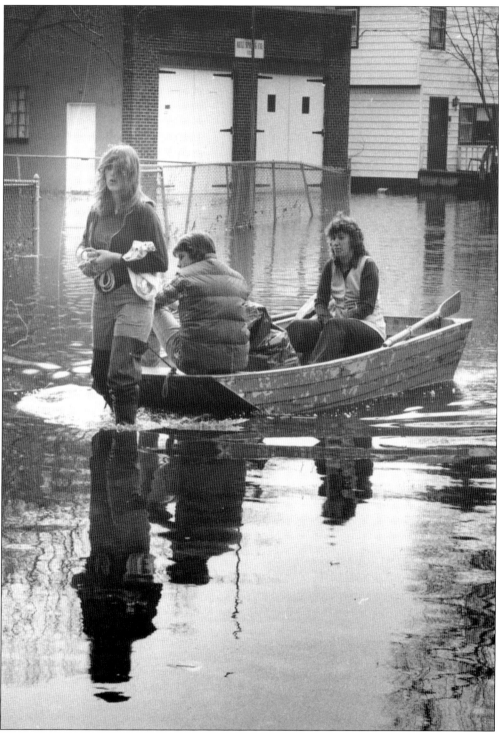

Robin Harty pulls her family across Fayette Avenue in 1980 as brother Gary and mother Pat manage their belongings. The Harty family was one of many forced to evacuate from their Wayne home that year. (Photograph by Joe Giardelli; courtesy of the *Record* archives.)

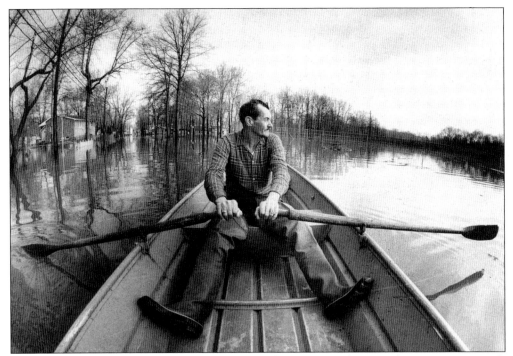

As Fayette Avenue in Wayne flooded in 1980, Emil Begyn provides an early morning tour with *Record* photographer Peter Karas to assess the damage to his neighborhood. (Photograph by Peter Karas; courtesy of the *Record* archives.)

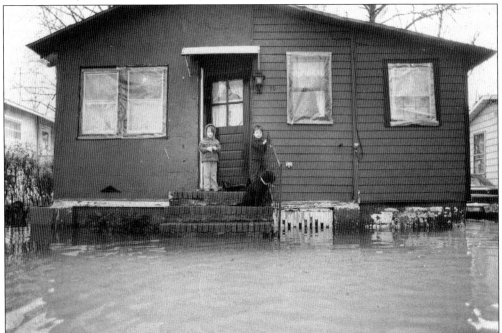

Terri Ann and Michael Filloon stand on the front steps along with their dog Stinky to observe the damage to their home and yard. Water quickly rose overnight, flooding their house in Wayne in 1980. (Photograph by Peter Karas; courtesy of the *Record* archives.)

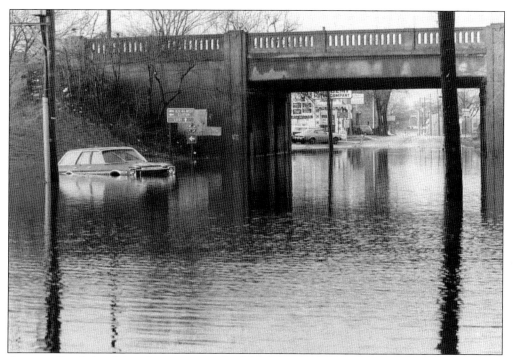

A car sits flooded on Main Street, just north of the Route 46 overpass in Lodi, in 1980. Otherwise, hazardous driving conditions limit pedestrians and automobiles from these water-filled streets. (Photograph by Ed Hill; courtesy of the *Record* archives.)

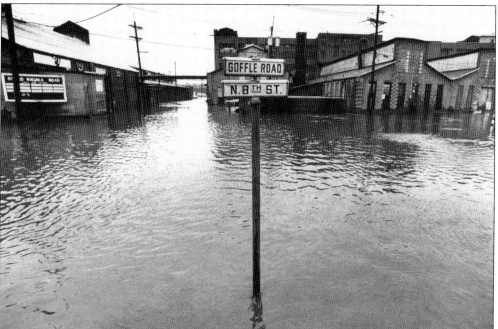

The intersection of Goffle Road and North Eighth Street in Hawthorne is swamped from the rising water in 1980. The overflow came from the nearby Passaic River that was overwhelmed by two days of heavy rainfall. (Photograph by Dan Oliver; courtesy of the *Record* archives.)

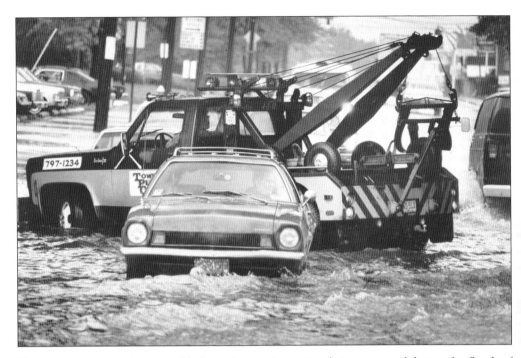

Tensions rise as motorists scramble for assistance in getting their cars towed during the floods of 1981 and 1982. The image above shows a tow truck assisting a motorist stranded on River Street in Hackensack after heavy downpour on May 12, 1981. The photograph below shows a frustrated motorist looking for assistance on Route 46 in Lodi on January 5, 1982. (Above, photograph by Peter Karas, courtesy of the *Record* archives; below, photograph by Rich Gigli, courtesy of the *Record* archives.)

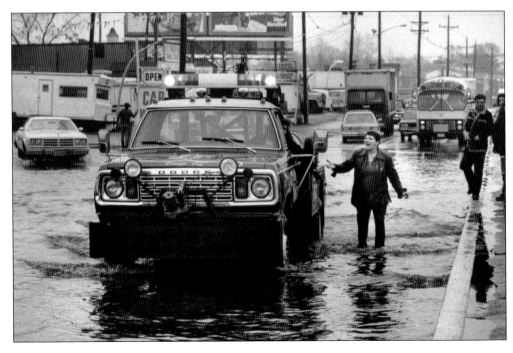

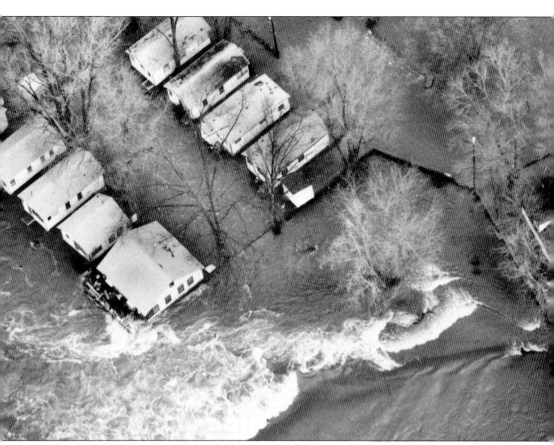

By 1984, basin floods had claimed 26 lives and caused $3.2 billion in property damage since the beginning of the century. On average, property in the basin sustains $100 million in damages. The frontal storm of April 1984 dumped two to eight inches of rain that resulted in three deaths, $590 million in property damage, and forced 6,000 residents to flee their homes. Hit hardest were Boonton, Little Falls, Lodi, Mahwah, Pine Brook, Pompton Lakes, Pompton Plains, and Wanaque. Most of the floodwater came from the Passaic River basin, which was already inundated with snow and rain from the previous six months. (Courtesy of the *Record* archives.)

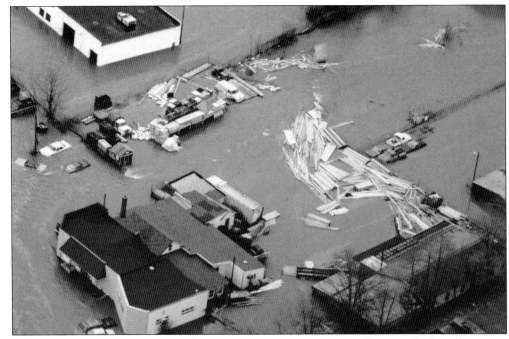

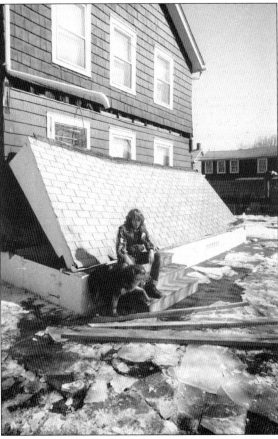

The storm that smacked northern New Jersey in April 1984 was termed the "big one," and it became the benchmark to measure all other storms. It was only eclipsed in 2011 with the arrival of Hurricane Irene. The flood was a turning point and prompted New Jersey legislators to seek assistance once again from the US Corps of Engineers. The photograph at left shows Wayne resident Robin Sanders with her dog on what used to be her front porch in 1984. (Above, photograph by Steve Auchard, courtesy of the *Record* archives; left, courtesy of the *Record* archives.)

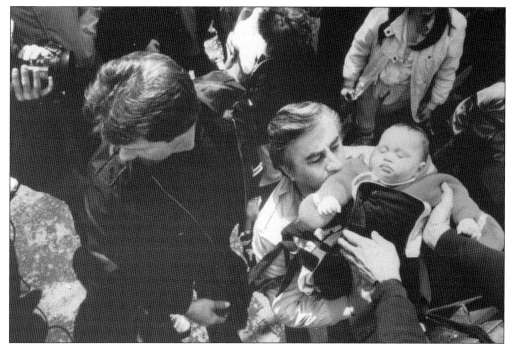

After the devastating flood of 1984, North Jersey residents were better prepared to take on the flood on April 6, 1987. The police, National Guard, and volunteers in Wayne evacuated families early on and moved them to Red Cross centers in places like Wayne Valley High School. In this photograph, Wayne mayor Louis Messercola (holding baby) helps in the evacuation of families from the Ryerson Avenue flood area. (Photograph by Rich Gigli; courtesy of the *Record* archives.)

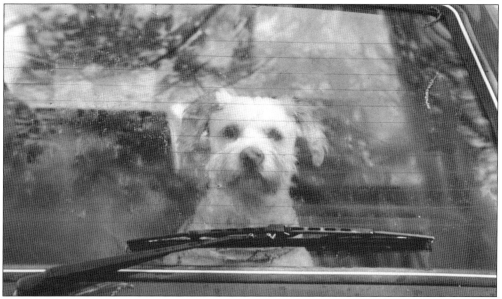

On May 18, 1989, heavy rain overflowed rivers and reservoirs, which in turn overflowed North Jersey. Roads turned into rivers, basements into swimming pools, and lawns into lakes. On the road, many cars stalled or crashed into each other. This pooch sat out the flood in an abandoned car in Oakland. (Photograph by Rich Gigli; courtesy of the *Record* archives.)

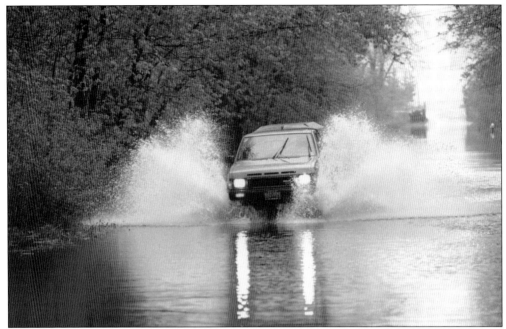

North Jersey experienced eight rainy days in May 1989. The pouring rain pushed the Saddle River over its banks in Lodi. In Wayne, police cruisers advised residents to move their cars to higher grounds on Hoffman Grove and Fayette Avenue. In Hillsdale and Westwood, homeowners saw Woodcliff Lake Reservoir spill over, sending cascades of water across the their lawns and basements; some of Lincoln Park's roads were submerged but continued to drain until late in the afternoon. This photograph shows a driver trying to navigate Lincoln Boulevard in Lincoln Park on May 17. (Photograph by Rich Gigli; courtesy of the *Record* archives.)

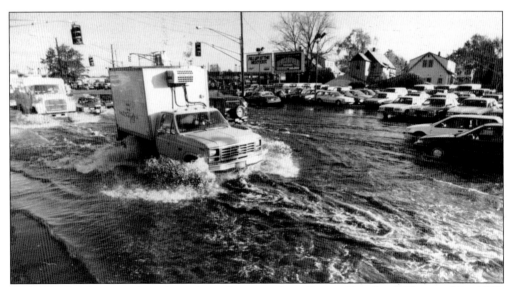

High tide floods cars and trucks making their way down Route 46 in Little Ferry in May 1989. The high tides caused many area roads to flood near tidal rivers. (Photograph by John Decker; courtesy of the *Record* archives.)

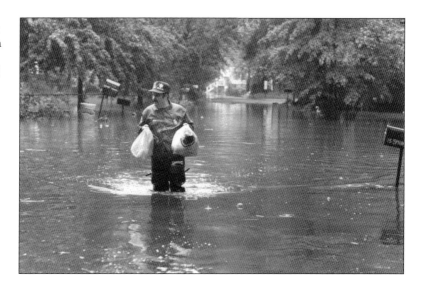

Preparing to wait out the flood, Jim Skelton walks down River Road with groceries in 1990. Skelton is a Hoffman Grove resident in Wayne. (Photograph by John Decker; courtesy of the *Record* archives.)

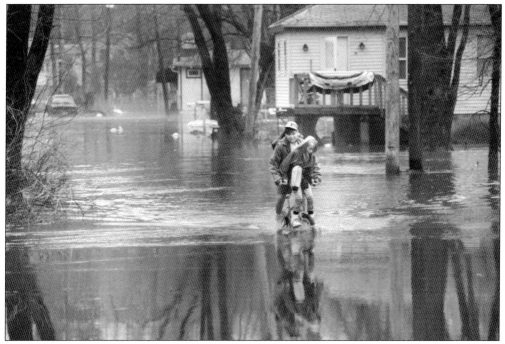

Twelve-year-old Ashley Oblinger of Lincoln Park pedals her bicycle with her eight-year-old friend Carrie Ackerman of Riverdale from flooded Midwood Avenue to higher ground. On Monday, March 29, 1993, Tim Collins, public information officer for Wayne's Office of Emergency Management, stated that many Wayne residents remained in their homes as overflowing waters from the Passaic River continued to rise. Residents of more than 350 homes in low-lying areas near the river were "strongly advised" to evacuate that Saturday. Rising water forced the closing of several streets on Sunday, including parts of Willowbrook Boulevard at Willowbrook Mall. Weekend rains atop melting snow caused the river to swell, making it crest one to two feet above flood stage. (Photograph by John Decker; courtesy of the *Record* archives.)

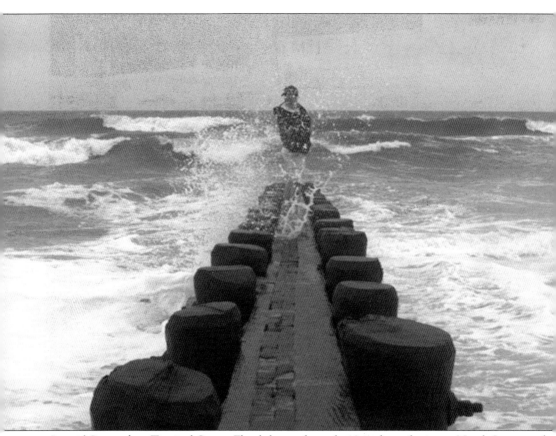

In mid-September, Tropical Storm Floyd dumped nearly 10 inches of rain on North Jersey and refilled reservoirs. The monster storm shut down highways, knocked out cell phone service in the area, and contaminated drinking water. Rivers raged out of control, spilling over into residential streets and forcing thousands of Passaic and Bergen Counties residents to flee their homes. The deluge weakened support beams under the Peckman River Bridge in Little Falls, causing a portion of Route 46 to sink nearly 10 inches. State transportation officials closed part of the busy highway for a week, disrupting business in the area and creating traffic gridlock. The two counties sustained about $17 million in damage from the storm. One bright note, the storm also snapped a six-month dry spell that almost brought on a severe drought in 1999. In this photograph taken on September 15, 1999, Michael Angelica of Parsippany-Troy Hills stands on a jetty on Long Beach Island where rough seas display the first signs of Hurricane Floyd as it makes its way up the East Coast. (Courtesy of the *Record* archives.)

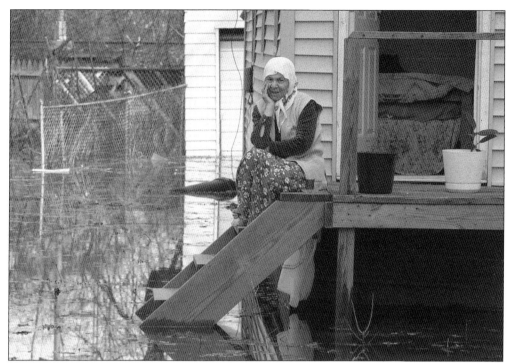

A Fayette Avenue resident in Wayne sits on her front porch, bewildered by the floodwaters that began to rise on March 30, 2005. (Photograph by Pier Francesco Baccaro; courtesy of the *Record* archives.)

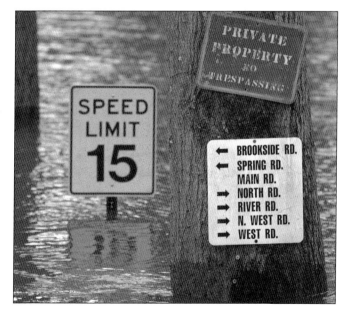

The Hoffman Grove area of Wayne received limited buyout programs for properties that were in chronic flood areas in 2005. While some residents expressed exasperation, others said they still would not leave the little community along the Pompton River, located near Routes 80 and 23. "It's a great place to live; everybody helps everybody," said resident Holly Young. On October 13 of that year, Wayne Township police used boats to evacuate residents from Hoffman Grove homes. (Photograph by Tariq Zehawi; courtesy of the *Record* archives.)

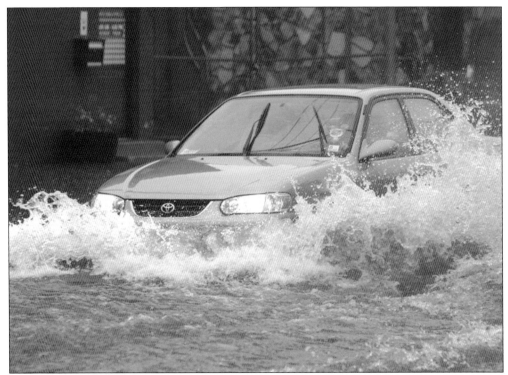

In 2007, a spring nor'easter dropped up to nine inches of rain on the area, flooding roads and basements and forcing much of Paramus to close. More than 1,500 residents in Bergen County alone had to be evacuated because of flooding. The Pompton and Passaic Rivers continued to rise on April 17, 2007, and major flooding unexpectedly hit Little Falls, Wayne, and other areas of Passaic County. "It was rushing in through the basement door and bubbling up from the floor; once it starts coming in from the [Passaic] river, you can't stop it," said Lyndhurst resident Gary Williams. In Hackensack, a driver moves slowly through floodwaters on Hudson Street, where the water was about a foot deep. (Photograph by Thomas E. Franklin; courtesy of the *Record* archives.)

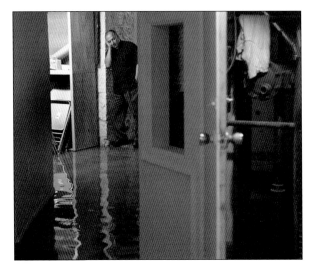

The basement of the rectory of St. Agnes Church in Paterson is flooded from heavy rains on July 21, 2009. The flooding occurred about 9:00 a.m. as heavy water volume caused the sewer to back up, sending potentially contaminated water cascading into the cellar. St. Agnes pastor Luis Rendon said the Roman Catholic church had just finished painting several rooms and classrooms in the basement, which was used for a prayer group, community events, and Alcoholics Anonymous group meetings. (Photograph by Elizabeth Lara; courtesy of the *Record* archives.)

Two

Floods of 2010

It was history in the making. The Passaic River was predicted to crest at 13 feet on Tuesday, March 16, 2010. In flood-ravaged Passaic County, where rising waters from the weekend had already forced the evacuation of hundreds of residents, the worst was yet to come.

On that day, experts predicted that the Passaic River would crest at nearly six feet above flood stage. That would put the river at the 13-foot marker, passing the modern-day high, 12.9 feet, set in 1984. The highest-known crest reached 17.5 feet in 1903 according to the National Weather Service.

Already hit areas, such as Wayne, Little Falls, Lincoln Park, Fairfield, Paterson, Totowa, and Woodland Park, reported submerged homes, requiring rescue workers to use boats to pull out residents. Numerous roads were submerged, doubling, tripling— even quadrupling—the commuting time for many drivers as they went from detour to detour. Meanwhile, thousands of residents remained without power because of downed lines, and several schools were closed or had early dismissal. The rising waters even closed Willowbrook Mall.

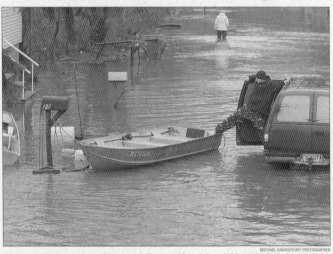

The *Record* newspaper warned its North Jersey readers on Monday, March 15, 2010, that the flooding was not over yet—and it was not. Severe flooding lasted until March 17 when waters finally began to recede. But soon after, before the end of the month, more rain flooded Passaic County in Wayne, Lincoln Park, Little Falls, and Pompton Lakes. (Courtesy of the *Record* archives.)

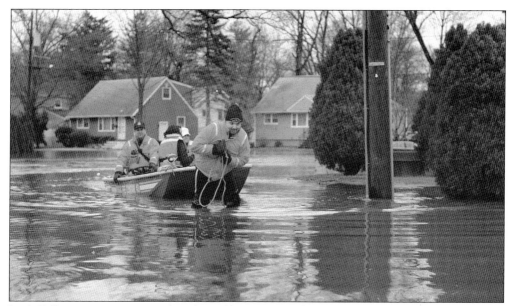

Little Falls emergency personnel performed boat rescues along William Street in Little Falls. Little Falls fire chief Jack Sweezy, seen in the back of boat in this photograph taken on March 13, 2010, steers while Dan Rusu from Company No. 3 helps pull the boat to higher ground. Overnight, the river rose very quickly, trapping many people in their homes. (Photograph by Adam Anik; courtesy of the *Record* archives.)

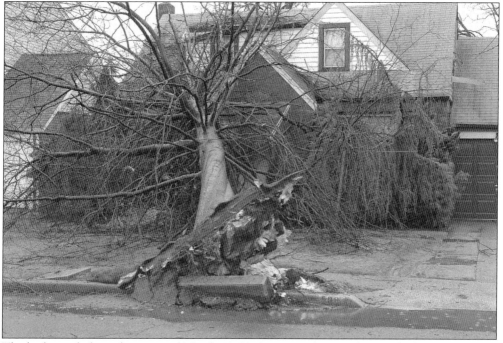

The high winds from the storm of March 13, 2010, uprooted a tree that crashed into this home on Beech Avenue in Saddle Brook. No one was injured in the mishap, but within the next two days, the nor'easter claimed the lives of two people who were killed by a falling oak tree. (Courtesy of the *Record* archives.)

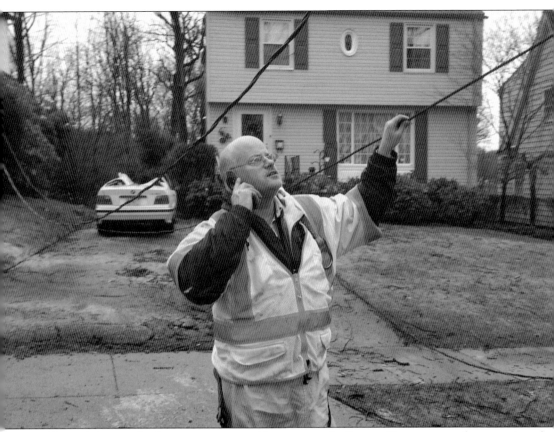

Tens of thousands of customers were without power in Bergen County as workers continued to clear trees and utility poles that toppled by the hundreds in the punishing storm. Officials declared a state of emergency in Bergen County, where crews from Public Service Electric and Gas Co. struggled to replace 70 utility poles and about 450 power lines that were damaged over the weekend. About 61,000 customers in Bergen County were without power two full days after the winds and rains reached their terrifying peak. The outages were blamed for school closures across the county. In this photograph from March 14, 2010, Comcast field representative Donald Russell examines the cable lines in front of a Linden Avenue home on Sunday after a tree tore out the overhead lines and crushed the BMW parked in the driveway. The severe winds and heavy rains in the weekend storm that tore through the area further softened the already wet ground and felled trees and caused property damage throughout the area, including towns like Verona. (Photograph Adam Anik; courtesy of the *Record* archives.)

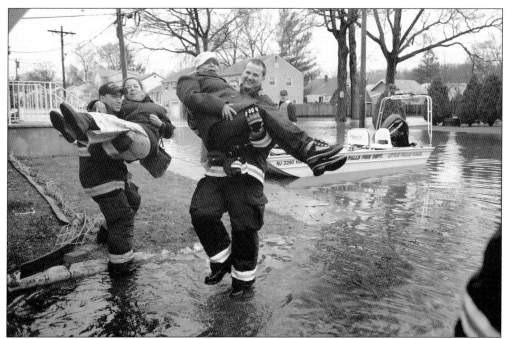

On March 15, Bobby Cali (left) from Little Falls Fire Department Company No. 3 lifts Martha Ochoa to safety while firefighter Ryan Gaffney assists Ena Valdez after the two were rescued by boat from their Lyttel Street home. (Photograph by Adam Anik; courtesy of the *Record* archives.)

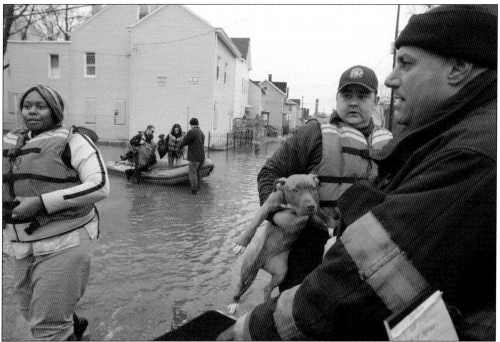

Paterson firemen rescue residents in a boat on Bergen Street in Paterson. The nearby Passaic River flooded much of the neighboring streets, as seen in this March 15, 2010, photograph. (Photograph by Thomas E. Franklin; courtesy of the *Record* archives.)

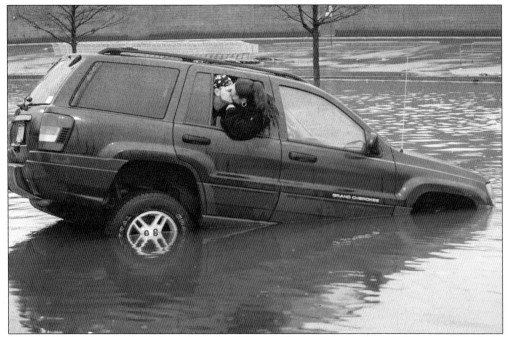

Nick Savage of Kearny and Sara LaBrunda of Roseland are stuck in a Jeep as they wait for help by Williowbrook Boulevard in Wayne. They could not exit the Jeep due to high water and a diesel spill from a nearby tractor-trailer on March 15, 2010. (Photograph by Chris Pedota; courtesy of the *Record* archives.)

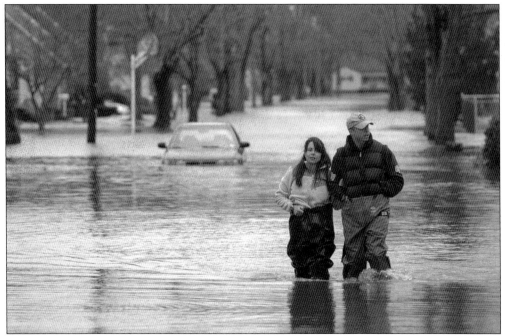

Floodwaters rise on Parkway and Williams Streets in Little Falls on March 15, 2010. Despite warnings, many people decided to stay in their homes. (Photograph by Demitrius Balevski; courtesy of the *Record* archives.)

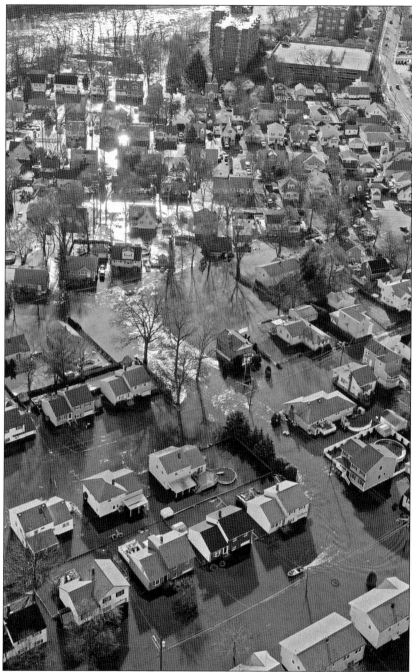

Record photographer David Bergeland took a helicopter ride on the morning of March 17, 2010, to get a bird's-eye assessment of the flooding caused by the cresting Passaic River after the weekend's memorable March maelstrom. This striking but grim view shows Little Falls experiencing some of worst flooding of the 2010 storm. Many neighborhood blocks west of the river and north of Main Street were under water. A man in a small motorboat can be seen in this photograph (lower right) gliding down Louis Street. He later steered into a driveway and puttered on into the open garage attached to a home. (Photograph by David Bergeland; courtesy of the *Record* archives.)

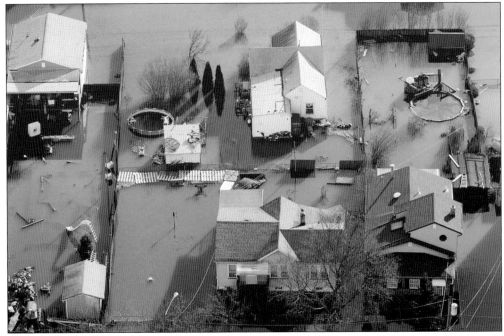

This is an aerial view of the impact of the water overflow from the Passaic River on Little Falls on March 17, 2010. About 400 homes were deluged with up to six feet of water. Water rushing into Little Falls ran more like a rapid, with fast-moving currents rushing down streets. In nearby Woodland Park, firefighters evacuated residents in flood zones and river water surrounded Memorial School. (Photograph by David Bergeland; courtesy of the *Record* archives.)

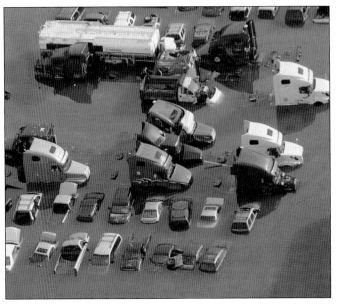

Seen here is an aerial view of a salvage yard off Newark Pompton Turnpike in Wayne on March 17, 2010. Many predicted that it would take days before Passaic County residents could return to their homes. With manpower in local communities stretched to the limit, the county's sheriff's department even called on narcotics detectives to help out. The department also bolstered rescue missions with boats, shuttle buses, and dive teams on standby. (Photograph by David Bergeland; courtesy of the *Record* archives.)

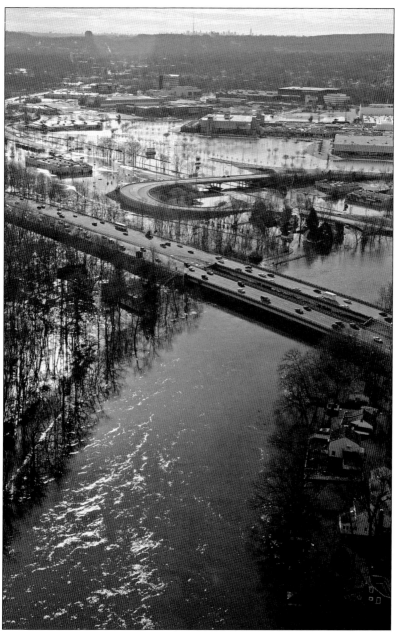

The Passaic River crested at five feet above flood stage on March 17, swamping whole neighborhoods with fast-moving water and muck as emergency workers continued to rescue people from their homes. In hard-hit Paterson, Mayor Jose "Joey" Torres declared a state of emergency, as 2,500 households were engulfed in water. In Wayne, the roads and parking lots around Willowbrook Mall resembled a lake. About 400 homes were deluged with up to six feet of water in Little Falls. In Lincoln Park, a house surrounded by water smoldered after a fire. In Garfield, oily, garbage-strewn water inundated a number of back lots, garages, and homes. New Jersey governor Chris Christie visited the storm-ravaged area later that day and met with officials at the Passaic County Office of Emergency Management. A state of emergency was declared in New Jersey on March 14, 2010. (Photograph by David Bergeland; courtesy of the *Record* archives.)

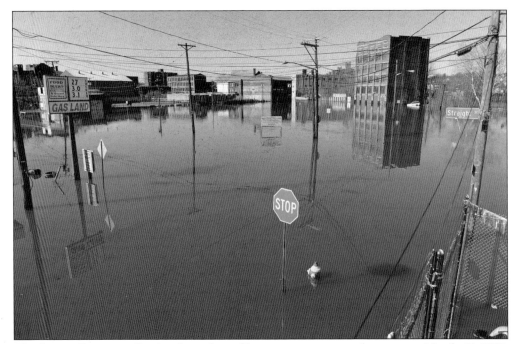

The Passaic River, swollen by three days of heavy rain, continued to rise on March 17, 2010, and caused moderate flooding. The body of water along River Street in Paterson rushed over the riverbank, flooding a swath of land between River Street and Straight Street in Paterson. (Photograph by Demitrius Balevski; courtesy of the *Record* archives.)

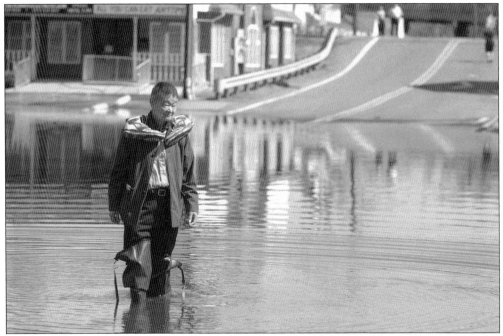

In great dismay, John Sun from Fayette Drive in Lincoln Park looks at the devastation near his home on March 18, 2010. All he could do was await the insurance adjusters. (Photograph by Demitrius Balevski; courtesy of the *Record* archives.)

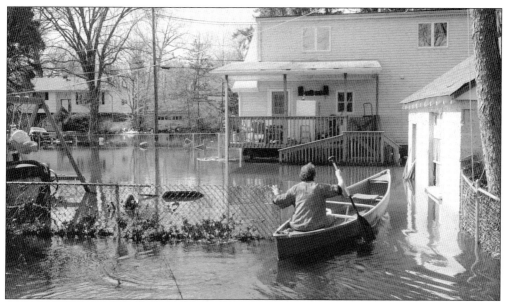

Mario Ziemba of Riverside Drive paddles his canoe through his backyard as he takes groceries home after shopping in Woodland Park. He parked his car at Willowbrook Mall and paddled home through the flooded waters of the Passaic River on March 18, 2010. (Photograph by Chris Pedota; courtesy of the *Record* archives.)

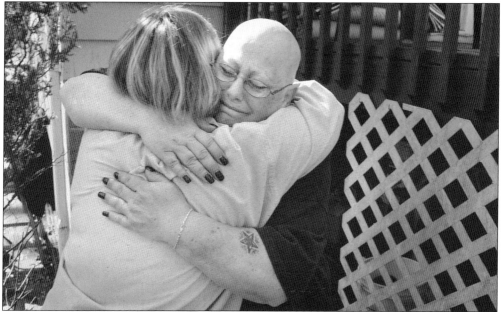

As water started to recede on March 20, 2010, volunteers came to help North Jersey residents with the long and arduous process of cleaning out homes that had been submerged in five feet of water. But residents did not have to work alone. Church groups offered free food and labor, Boy Scouts delivered boxes of cleaning supplies, and neighbors loaned out wet vacs and water pumps. Home owner Valerie Erling (right) hugs Pauline McKeown. McKeown was helping her carry items from the flood-damaged basement. (Photograph by David Bergeland; courtesy of the *Record* archives.)

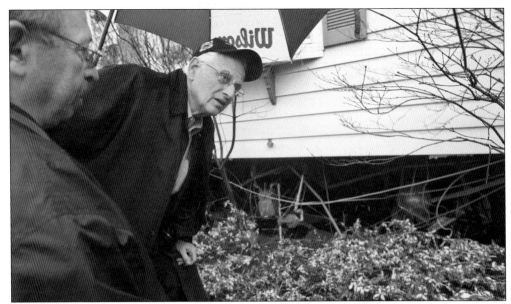

By March 22, 2010, Rep. Bill Pascrell Jr. inspected flood damage in Pompton Lakes. It rained again that day as Pascrell stood in front of the flood-ravaged Pompton Lakes home of Ignatius "Iggy" Mongelli, which was made uninhabitable when floodwaters caused its foundation to cave in, snapping a gas line. (Photograph by Chris Pedota; courtesy of the *Record* archives.)

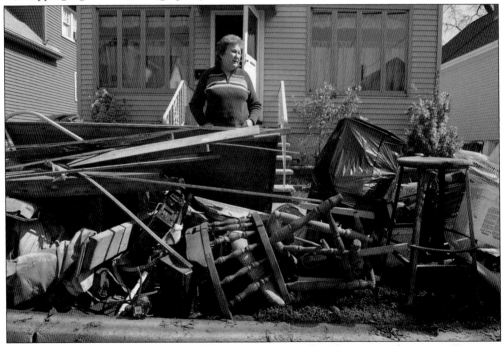

By March 23, 2010, power was restored, but many were still without gas or hot water. Everyone was focused on cleaning up and salvaging water-drenched valuables. Clean-up efforts continued in Woodland Park and Little Falls. In this image, Ann Russomanno stands in front of her Zeliff Avenue home. Unfortunately, when her husband fell ill last year, they were no longer able to afford flood insurance. (Photograph by Amy Newman; courtesy of the *Record* archives.)

More rain started to fall on March 28, 2010. Though nothing close to the deluge of two weeks prior, rising floodwaters led to many roads being closed. Officials were ready to evacuate residents and open shelters in Wayne, Lincoln Park, Little Falls, and Pompton Lakes, but that did not prove to be necessary. Among the major arteries closed because of flooding that Tuesday were Route 20 southbound in Paterson, Riverview Drive in Totowa, Presidential Boulevard in Paterson, and the Arch Street Bridge in Paterson. Letter carrier Keith Cordner is pictured here braving the elements to deliver mail in Paterson. (Photograph by Amy Newman; courtesy of the *Record* archives.)

Eileen Carroll of Ryerson Avenue in Wayne speaks to her best friend on the phone while walking up her street on Wednesday, March 31, 2010. Carroll said that she had a few inches of water in her home all week. The Passaic River continued its rise on April 1, and street flooding worsened again. Flood warnings were issued for a second time, as the river remained above flood stages. (Photograph by Kevin R. Wexler; courtesy of the *Record* archives.)

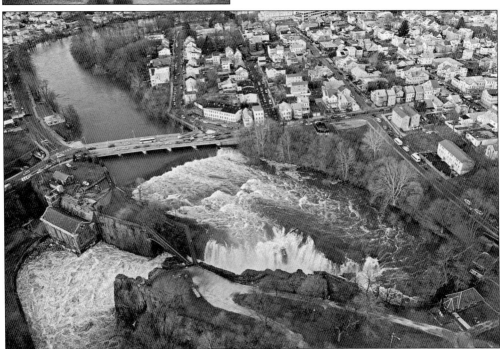

The Passaic River crested at five feet above flood stage in March 2010, swamping whole neighborhoods from Paterson to Little Falls. Workers continued to rescue people from their homes. In Wayne, the roads and parking lots around Willowbrook Mall became a lake. Some 400 homes were deluged with up to six feet of water in Little Falls. In Lincoln Park, a house completely surrounded by water smoldered after a fire. (Photograph by David Bergeland; courtesy of the *Record* archives.)

Three

FLOODS OF 2011

Two major floods overwhelmed North Jersey in 2011. The first arrived in March 2011, and the more devastating storm, Irene, came in August 2011.

With the March flooding, the Passaic River reached close to 12 feet in Little Falls, almost five feet above the flood stage. As a result, Paterson officials closed the West Broadway, Temple Street, Arch Street, and Haledon Avenue bridges that cross the river in the northwestern part of the city. Evacuations took place in Little Falls and Hawthorne, while in Elmwood Park, five sections of River Drive across the borough were closed as the Passaic River flooded low-lying areas.

Irene was often compared to the 1903 "flood of record" as the most destructive flood in this region. Its damage ranks as the seventh costliest hurricane in United States history. On August 25, 2011, Gov. Chris Christie declared a state of emergency for New Jersey. In northern New Jersey, record rainfall in the Passaic River crested at 14.19 feet, seven feet above the stage level. Almost 1,700 people had to be evacuated, and 300 roadways were blocked.

Flooding was apparent as early as March 10, 2011, in the McBride Avenue neighborhoods of Woodland Park. In this image, a home on Bergen Boulevard in Woodland Park uses a sump-pump to drive water out from its interior. (Photograph by Pierfrancesco Baccaro; courtesy of the *Record* archives.)

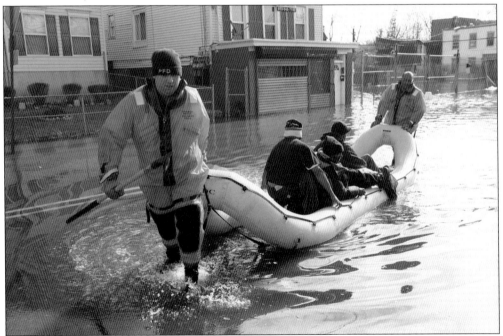

Paterson firefighters Michael Hook (left) and Jerome Hunter remove three men from a home on Presidential Boulevard at Arch Street on the morning of March 12, 2011. One of the men, 53-year-old Anthony Stradford of Paterson, said that he was able to persuade the other residents to evacuate due to the rising floodwater and the risk of a fire. (Photograph by Tariq Zehawi; courtesy of the *Record* archives.)

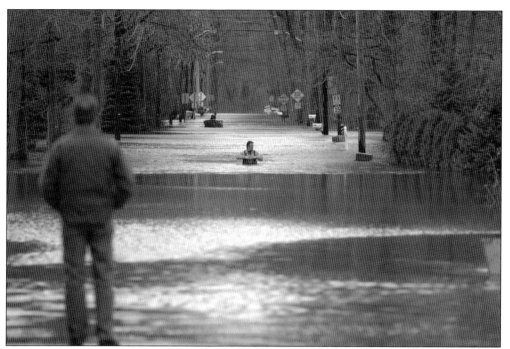

This powerful March storm forced 8,500 North Jersey residents from their homes due to flooding and wind damage. Back-to-back floods brought almost six feet of water to some homes. "This has been an incredible 10 weeks. Two blizzards, two nor'easters and now we're going to be having our second flood in a couple of weeks here," Gov. Chris Christie said. An estimated 3,200 homes were either heavily damaged or destroyed, and Passaic County suffered an estimated $9 million in damage. In this photograph, a man up to his chest in floodwater walks up Ryerson Avenue in Wayne on March 13, 2011. (Photograph by Thomas E. Franklin; courtesy of the *Record* archives.)

On March 12, 2011, the Passaic River reached 12 feet, the highest since 1984 and more than 5 feet above flood stage. Residents along the Passaic and Pompton Rivers were hit hardest. In this image, Steve Veliky fords Pine Street and Dawes Highway in hip waders from his Pompton Lakes home. (Photograph by Thomas E. Franklin; courtesy of the *Record* archives.)

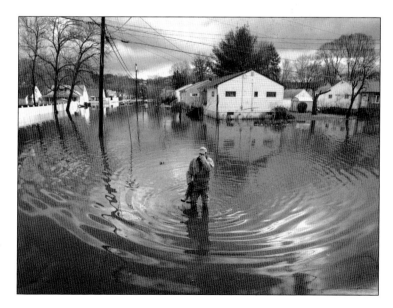

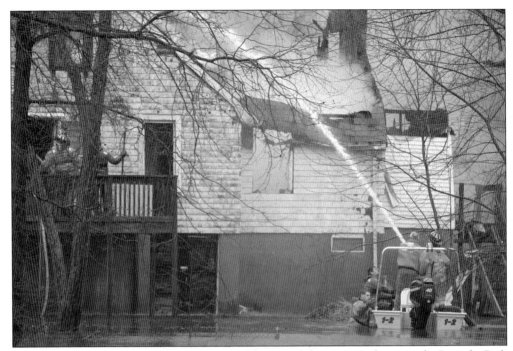

Wayne Fire Department members are assisted by one of their marine boats as the Lincoln Park Fire Department battles to put out a house fire on a flooded Kopp Street in 2011. (Photograph by Tariq Zehawi; courtesy of the *Record* archives.)

In Oakland, water, like a roaring rapid, rushed down Roosevelt Boulevard on March 11, 2011, damaging trees and automobiles along its path. (Photograph by Paula Barbagallo; courtesy of the *Record* archives.)

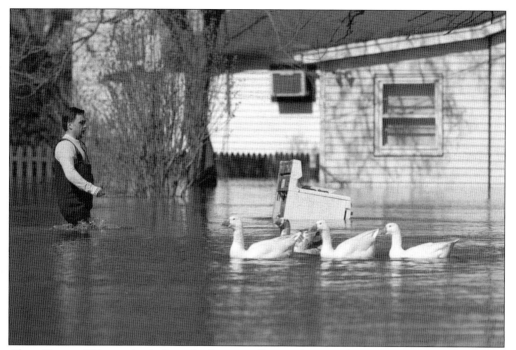

Aktug Kayat of Wayne checks in on his home on Fayette Avenue after continuous rain flooded his entire neighborhood. Kayat said that he just finished remodeling his home after destruction from the floods of the previous year. (Photograph by Tariq Zehawi; courtesy of the *Record* archives.)

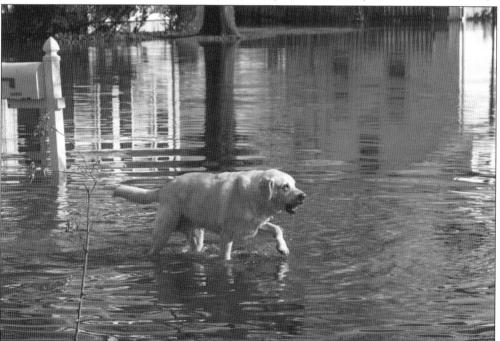

The Rockaway River, swollen and raging after the storm, continued to flood areas throughout North Jersey. Tucker the dog is all tuckered out after his romp in the floodwaters in front of his Third Avenue home in Denville. (Photograph by Jerry Dalia; courtesy of the *Record* archives.)

On March 12, 2011, Governor Christie toured some of the flood-ravaged communities in Passaic and Morris Counties and reassured residents that the state was pushing ahead with short- and long-term solutions to bring relief. He arrived by helicopter in Wayne and walked through neighborhoods in Little Falls, Pequannock, and Pompton Lakes. Little Falls resident Donna Battista told the governor that she has lived in the township since 1984 and complained that flooding has become a constant problem. "Something has to be done," she told the governor. "And it has to be a little faster." (Photograph by Elizabeth Lara; courtesy of the *Record* archives.)

A rescue worker is harnessed to a rope as he goes through floodwaters to rescue stranded residents in Saddle River on June 23, 2011. Emergency personnel also had to use a truck to aid stranded victims. (Photograph by Tariq Zehawi; courtesy of the *Record* archives.)

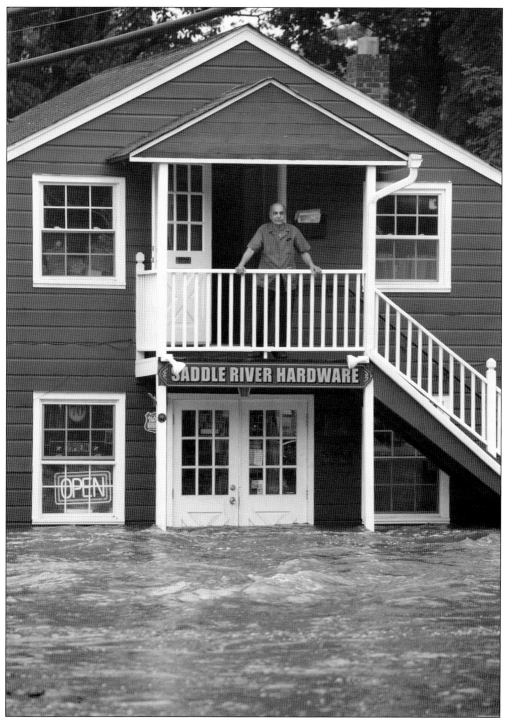

A flash flood left Sakir Khan stranded on the second floor of the Saddle River Hardware store on East Allendale Road at West Saddle River Road. Emergency crews later arrived to rescue him and fellow resident Charlene Mabe (not shown). (Photograph by Tariq Zehawi; courtesy of the *Record* archives.)

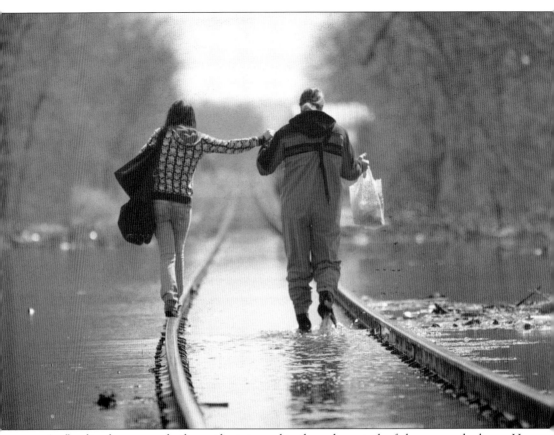

As flooding began to subside, residents turned to the arduous task of clean up and salvage. Here, a man helps his wife keep her balance so that she does not have to get her feet wet as they leave their home on Fayette Avenue. But attempts to stay dry were almost futile five months later, when the fury of Hurricane Irene returned that year. (Photograph by Tariq Zehawi; courtesy of the *Record* archives.)

Four

HURRICANE IRENE

On Friday, August 26, 2011, Governor Christie warned, "Get ready now" for Hurricane Irene, telling residents to expect heavy rains and high winds. The dangerous storm that was running its course through the Bahamas was expected to hit New Jersey later the next day. By Saturday morning, NJ Transit and PATH suspended rail service, followed by buses and light rail by 6:00 p.m. Within a few hours, the Garden State Parkway was closed to southbound traffic near the shore. Announcements were made by the Port Authority that five airports would shut down. Forecasts predicted rainfall to begin by 8:00 a.m. the next day. On Sunday, August 28, Hurricane Irene blasted through North Jersey, splintering trees, leaving tens of thousands in the dark, and killing at least one. More than eight inches of rain fell that day, and thousands were forced from their homes. A Wanaque man died after being pulled into a fast-moving stream. Some rescue operations by local firefighters took place in New Milford, saving at least 200 people, but operations were suspended around 7:30 p.m. as floodwaters began to move too fast.

On Tuesday, August 30, 2011, Irene delivered its strongest punch to North Jersey with rivers swollen to record-breaking levels, large-scale evacuations, millions of dollars in damage, scores of road closures, and its cities in virtual lockdown. All rivers had crested by late afternoon, but flood levels would continue to hold for days to come. With power outages still in effect, limited supplies of gas, a wide range of environmental hazards looming, and large-scale evacuations still in place, Governor Christie said that North Jersey was on "too-familiar ground" because it was his third flood-related visit to the region in 19 months.

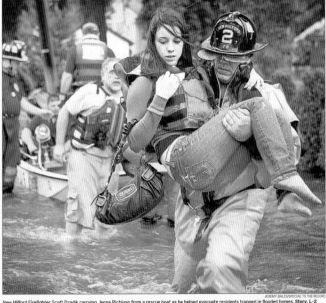

The *Record*'s front page on August 29, 2011, shows the chaos that Hurricane Irene brought to many towns of North Jersey. With over a billion gallons of water pouring over its dams, massive flooding was reported throughout both counties. As new flood-stage records were being set, it was evident the storm was more severe than the one experienced in March of that year, and within time, it would be compared to the historic flood of 1903. (Courtesy of the *Record* archives.)

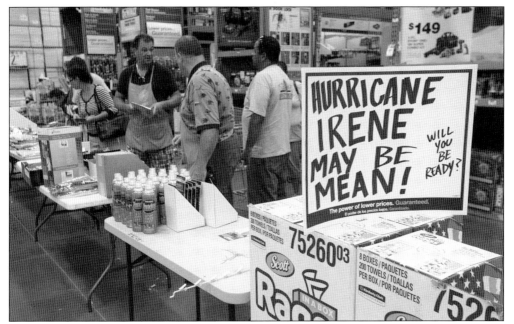

On August 26, North Jersey was on alert and loaned out Passaic County jail inmates to fill sand bags; shelters and backup shelters were pinpointed, and fliers were given out informing residents about evacuation parking. Reverse 911 service and high-water vehicles were on standby. Local and county shelters were identified, and megastores like this Home Depot in Lodi showcased the essential tools to help residents prepare for the worst. (Photograph by Michael Karas; courtesy of the *Record* archives.)

Jason Post moves a table to higher ground on August 26 in the garage at the Hillsdale home of his in-laws, Judi and Joseph Esola. They live near the Pascack Brook and had been flooded three times in 2011. (Photograph by Leslie Barbaro; courtesy of the *Record* archives.)

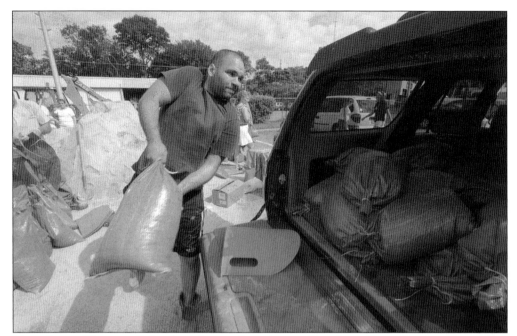

Mario Perez of Pompton Lakes loads his truck on August 27 with sandbags. He wanted to collect about 130 to protect his home. Residents took advantage of the free sandbags provided by the Passaic County Sheriff's Department as the flood-prone town braced for a monster storm. This was the first time the free service had been provided. (Courtesy of the *Record* archives.)

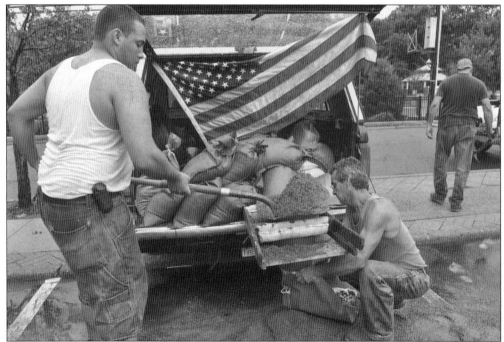

As the Passaic River at Little Falls reached flood stages at 11.6 feet on August 28, Woodland Park residents Matthew Vargas and Angello Vegas are pictured filling sandbags in Little Falls. (Photograph by Demitrius Balevski; courtesy of the *Record* archives.)

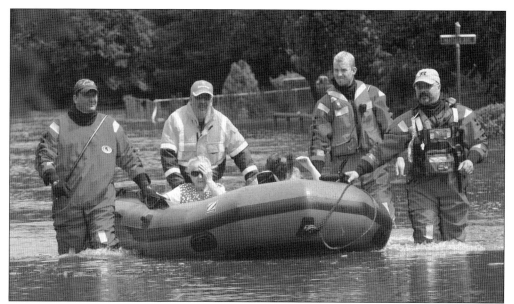

The Pompton Lakes Fire Department evacuated three elderly women from their home on August 28, 2011. All three were trapped in their homes by the raging flood. The rescuers guided them to safety on Riverview Road in Pompton Lakes. (Photograph by Chris Pedota; courtesy of the *Record* archives.)

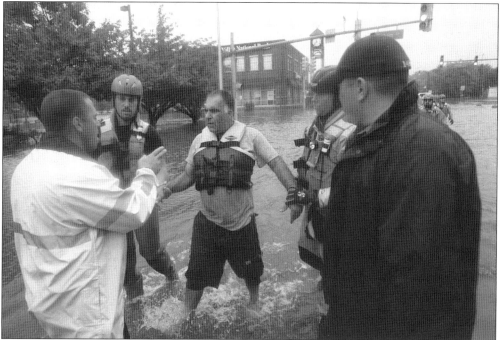

On August 28, police arrested Ted Bobo (center), whose canoe capsized as he and three friends paddled through Lodi's submerged streets. Emergency workers in motorboats searched for him for several frenzied minutes before pulling him from the water. Bobo later said he was not aware of restrictions on boating in the floodwaters. All four men survived. (Photograph Kevin R. Wexler; courtesy of the *Record* archives.)

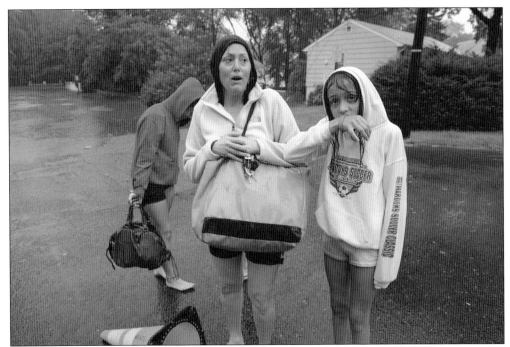

Tracy Lombardy (center) and her children left their home on Lafayette Avenue in Westwood after it was flooded with five feet of water. On this day, August 28, many nearby homes were ordered to evacuate. (Photograph by Chris Monroe; courtesy of the *Record* archives.)

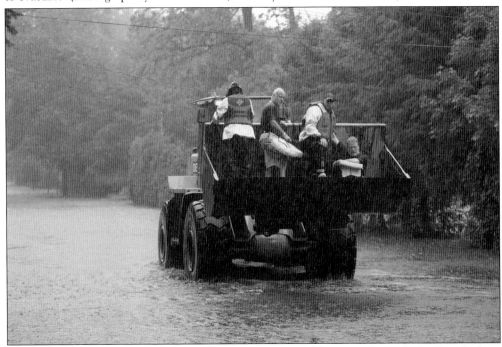

Firefighters from Ridgewood and Ho-Ho-Kus ride down Franklin Turnpike in the bucket of a front loader looking for residents in need of rescue on August 28. (Photograph by Thomas E. Franklin; courtesy of the *Record* archives.)

Water from the Pompton Dam crashes into a bridge on Hamburg Turnpike in Pompton Lakes on August 28. The water eventually rose above the bridge, swamping the street. (Photograph by Chris Pedota; courtesy of the *Record* archives.)

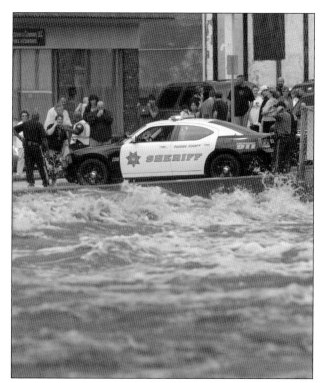

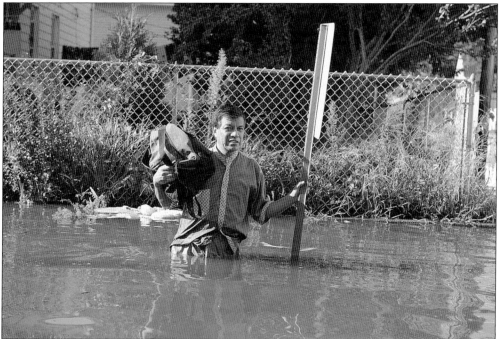

In East Rutherford, Anthony Chavez of Wallington Avenue is stuck trying to get to his house. Waist-deep in water, he was unable to continue the fight and waited for a rescue boat to pick him up. Minutes later, a rescue boat took him to safety. (Photograph by Chris Monroe; courtesy of the *Record* archives.)

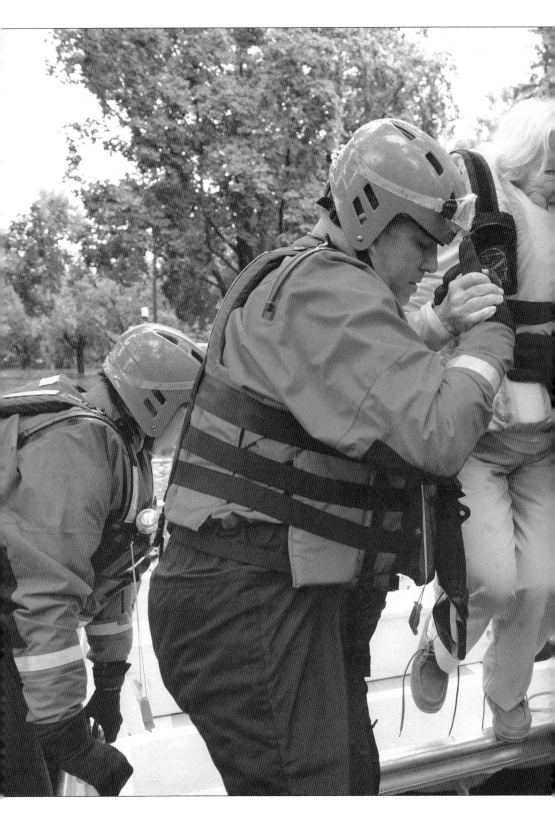

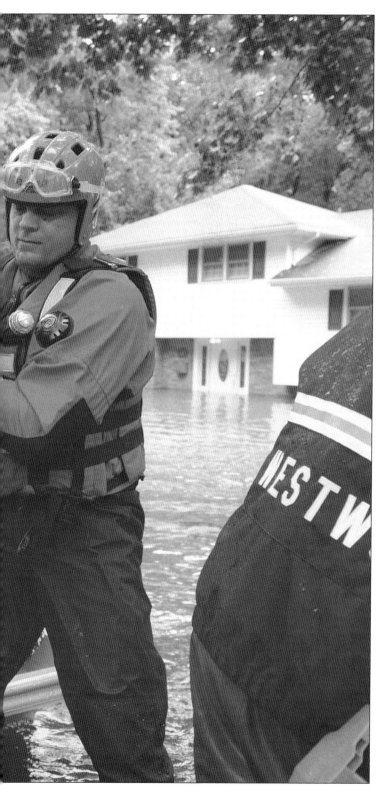

In Westwood, emergency sirens blew around 8:30 a.m., and some residents saw water racing to fill up their house. The police were not able to immediately respond to calls because the current was too strong. Officials advised families to go to the second floor of their homes. Some feared that the water would eventually reach even higher levels. Eventually, firefighters rescued most inhabitants by boat on August 28, 2011. This photograph shows Dorothy Nolan of Harding Avenue in Westwood getting some assistance from Westwood rescuers. (Photograph by Chris Monroe; courtesy of the *Record* archives.)

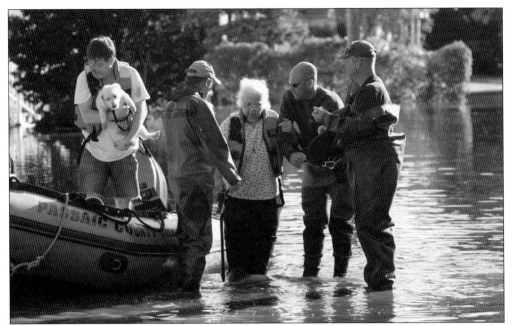

On August 29, 2011, seventy-four-year-old Helen Head and her son William, 47, evacuated from their home on Riverview Road in Pompton Lakes with their dog, Coppy. Passaic County Sheriff's Department Scuba Unit is shown helping with evacuations in the flooded areas along the Ramapo River. Many credited the early and mandatory evacuations in North Jersey as key to saving lives during Irene's flooding. (Photograph by Chris Monroe; courtesy of the *Record* archives.)

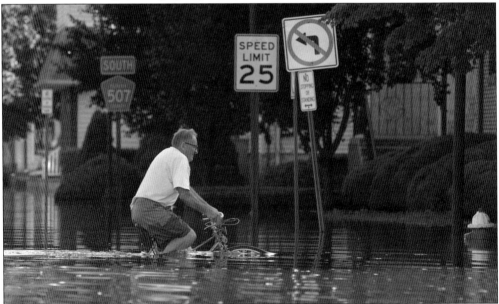

On August 31, 2011, in some areas of Wallington, water climbed to the top of first-floor windows. Enormous quantities of water rushed from nearby dams, and residents of the entire low-lying section along the Passaic River were ordered to evacuate the area. This photograph shows a man riding a bicycle at Locust and Main Avenues in Wallington. (Photograph by Michael Karas; courtesy of the *Record* archives.)

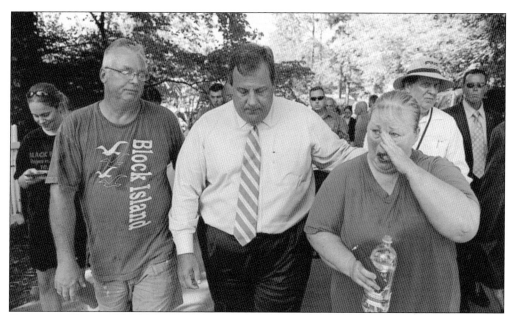

Governor Christie speaks with Wayne resident Valerie Meter, whose North Avenue home was damaged by flooding on August 31, 2011. (Photograph Tyson Trish; courtesy of the *Record* archives.)

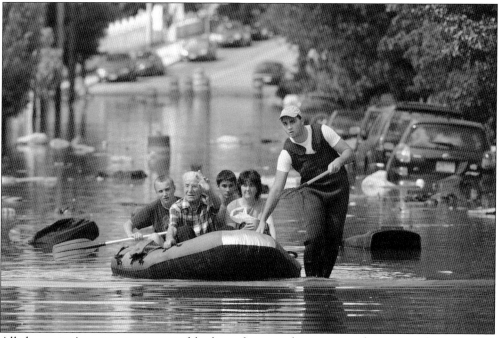

All the region's major rivers crested by late afternoon but continued to pummel water-weary residents on August 31, 2011. Governor Christie described Irene as the worst storm in a century. Assemblyman Scott Rumana said it was "unquestionably the biggest flooding event of our lifetimes." In this photograph, Max Zaccone pulls Edward Chmielowiec and an unidentified woman to safety in Wallington. Luke Podstawski and Kamil Sorotowicz (sitting in the rear) assist. (Photograph by Chris Monroe; courtesy of the *Record* archives.)

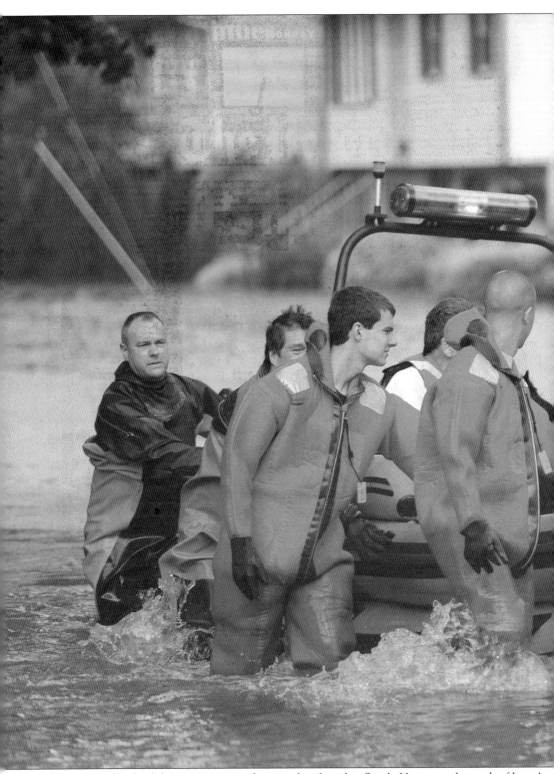

Pompton Lakes firefighters transport a dog to safety from his flooded home at the peak of Irene's

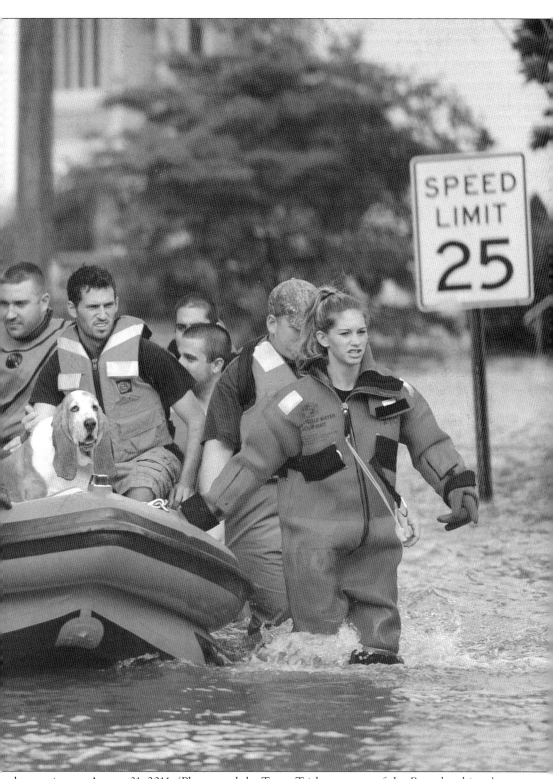
destruction on August 31, 2011. (Photograph by Tyson Trish; courtesy of the *Record* archives.)

Bill Bernard Jr. bows his head as elected officials hold a press conference on his front yard regarding the flooding situation. Bernard's home, located on Peabody Avenue in Lyndhurst, was damaged from the recent storm. (Photograph by Kevin R. Wexler; courtesy of the *Record* archives.)

In Little Falls, residents of the flood-prone area band together along with members of the Little Falls council to lead a flood-awareness walk in support of a redesign of the Beatties Dam. (Photograph by Demitrius Balevski; courtesy of the *Record* archives.)

Five

Hurricane Sandy

Late in the evening on Tuesday, October 29, 2012, the skies turned gray, and a fierce wind pushed violently against North Jersey. By the following morning, the intense wind gusts toppled trees and power lines; within hours more than 150,000 residents lost power. The following day, the rainfall and wind reached their peak, and many called it the worst in the state's history. By Wednesday, almost 320,000 utility customers in Bergen and Passaic Counties were without power. Hardest hit were the towns of Moonachie and Little Ferry. The impact of the storm and rain was unprecedented, prompting both Governor Christie and President Obama to tour the storm-damaged areas of New Jersey that day.

 A man from Bergen County died when he drove into floodwaters and drowned. Two other people from Passaic County and a couple from Morris County died from falling trees. A police officer from Wayne was seriously injured when a tree fell on his police car.

 With many still in the dark and fuel scarce, residents began to pick up the pieces. After floodwaters began to recede, many residents began the clean-up process. Most began to realize that food, gas, and supplies required long waits. It took almost a week after the storm for electricity and gas to return to the residents, but many homes have still not recovered from the disaster.

On October 31, 2012, President Obama comforts Donna Vanzant, owner of the North Point Marina on East Shore Drive in Brigantine. Boats from the marina ended up in the street after Hurricane Sandy hit New Jersey. Governor Christie also arrived that day to provide support. (Photograph by Kevin R. Wexler; courtesy of the *Record* archives.)

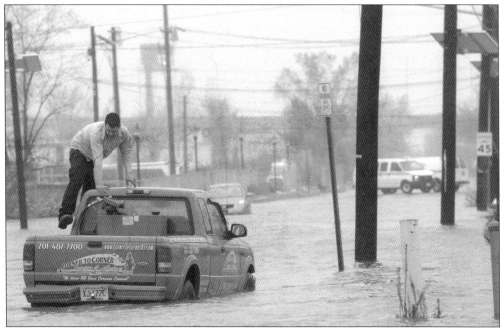

On October 29, 2012, a driver got out of his disabled truck on South River Street in Hackensack. Later, a larger truck from the same company pushed his truck out of floodwaters. The road was closed due to flooding. (Photograph by Elizabeth Lara; courtesy of the *Record* archives.)

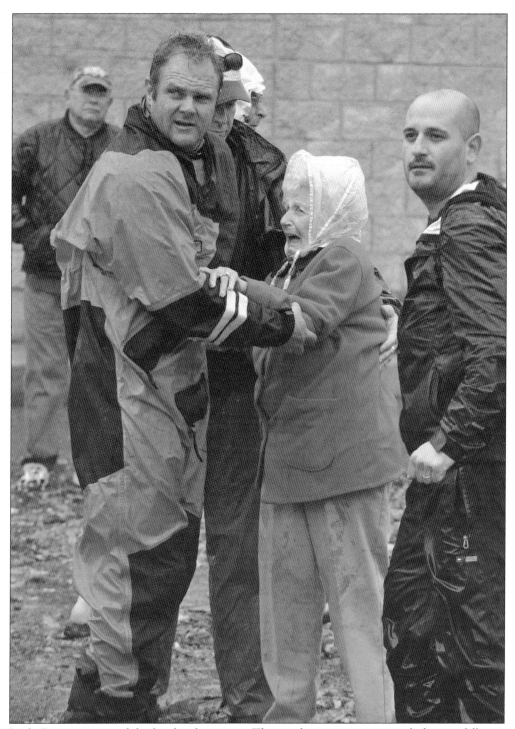

Little Ferry was one of the hardest hit towns. The quick-passing storm terrified many folks on October 30, 2012. Evacuations for these residents in Little Ferry at the intersection of Liberty and Eckel Streets took place one day after the storm. (Photograph by Chris Monroe; courtesy of the *Record* archives.)

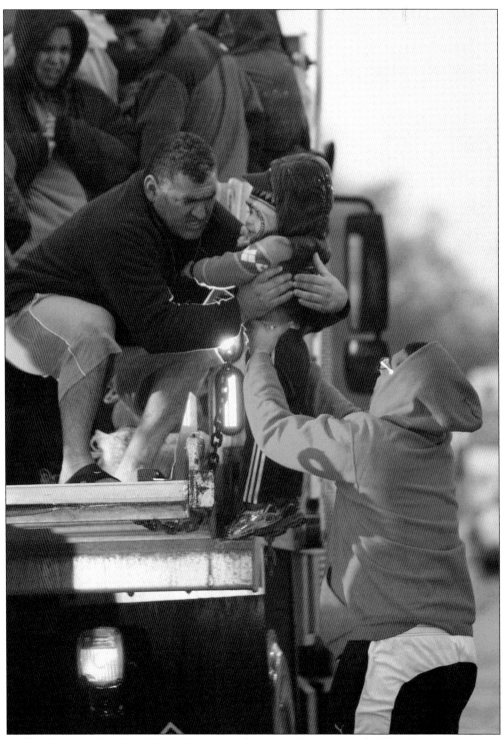

In Teterboro, on October 30, 2012, evacuated area residents stepped off trucks at the staging area at Bergen County Technical School. (Photograph by Tariq Zehawi; courtesy of the *Record* archives.)

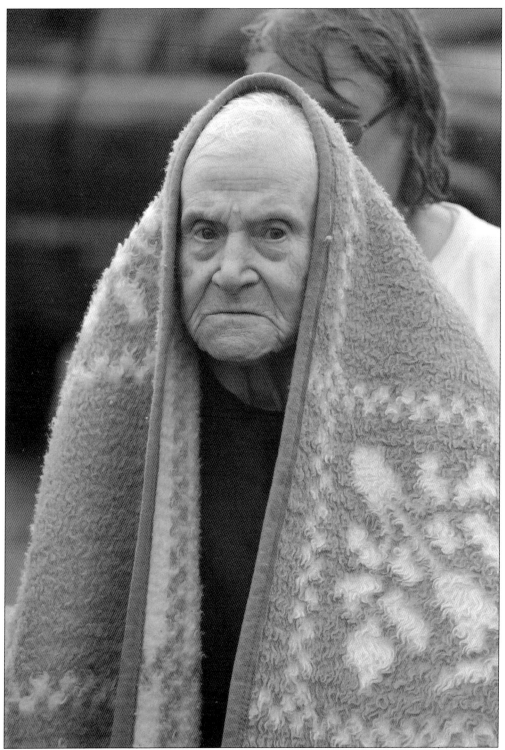

This elderly woman was among the residents from Little Ferry waiting to be evacuated on October 30, 2012. (Photograph by Tariq Zehawi; courtesy of the *Record* archives.)

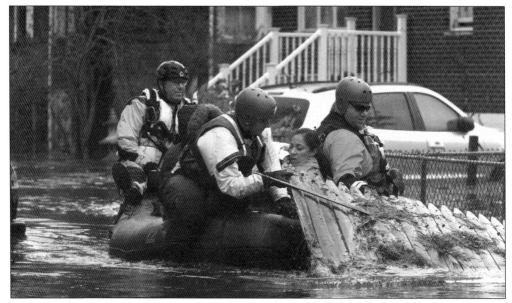

Rescue workers assist Senegida Tomasetti, her one-year old daughter, and her mother, Esperanza Medina. They were evacuated from their home in Little Ferry on October 30, 2012. During the attempt, the rescue boat hit loose fence, delaying the operation. (Photograph by Tariq Zehawi; courtesy of the *Record* archives.)

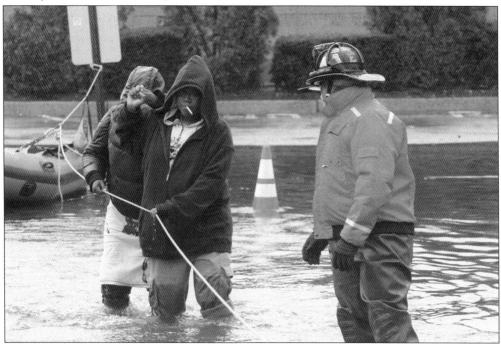

Lyndhurst first responders evacuated guests from the Quality Inn on Polito Street on October 30, 2012, after rising waters deemed it uninhabitable. Most of Lyndhurst was plagued by flooding, downed trees and wires, and extensive power failures. Earlier, the Public Service Electric and Gas Company (PSE&G) reported between 5,000 and 10,000 customers without power in the township. (Photograph by Chris Pedota; courtesy of the *Record* archives.)

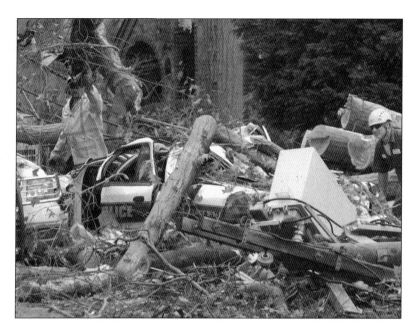

A police officer was hurt when a large tree crashed on his patrol car while he was at the scene of a ruptured gas line at the height of Hurricane Sandy on October 30, 2012. Luckily, the officer survived. (Photograph by Brian Hester; courtesy of the *Record* archives.)

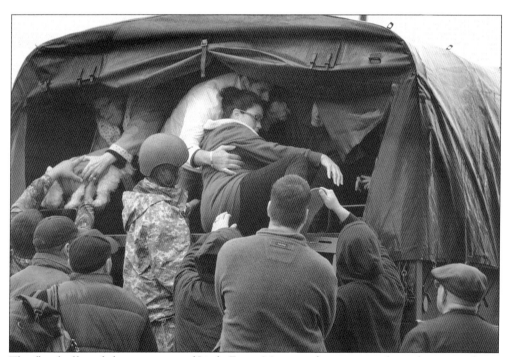

The flood affected three-quarters of Little Ferry. Many residents were at first reluctant to leave their home, but as the water poured through the narrow residential streets, crashing into the basements of small single-family homes and apartment complexes, many were convinced it was time to move to nearby shelters. In this image, residents from Little Ferry evacuate to safer areas in Bergen County. (Photograph by Amy Newman; courtesy of the *Record* archives.)

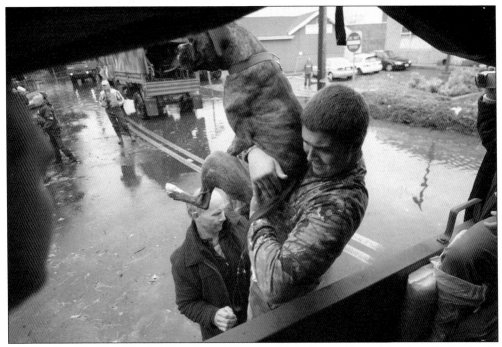

On October 30, 2012, Frank Mercadante, 18 years old, is shown lifting Max into the back of a rescue truck. Max and his owner, Mark Luchetta, were rescued from Columbus Avenue in Little Ferry. Garfield resident and Good Samaritan John Mercadante used his own truck to rescue residents stranded in Moonachie and Little Falls. (Photograph by Amy Newman; courtesy of the *Record* archives.)

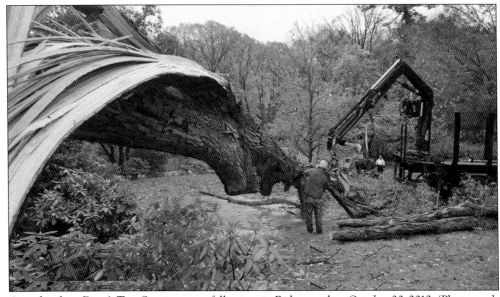

A worker from Dave's Tree Service cuts a fallen tree in Ridgewood on October 30, 2012. (Photograph by Mitsu Yasukawa; courtesy of the *Record* archives.)

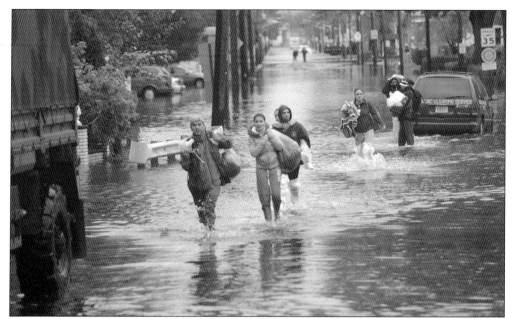

With valuables placed in plastic bags, Moonachie residents rush to catch a rescue truck to take them to safety on October 31, 2012. (Photograph by Amy Newman; courtesy of the *Record* archives.)

On October 31, 2012, traffic was backed up for a half mile, and drivers had to wait for up to an hour to fill up their tanks and canisters. After losing power, many Bergen County residents struggled for access to food, gas, or even a charge of their cell phones. During the cold weather, they had to move from one location to another, looking for a warm place to sit and rest. The line for gas was more than an hour's wait at the Delta gas station on Broadway in Fair Lawn. (Photograph by Tariq Zehawi; courtesy of the *Record* archives.)

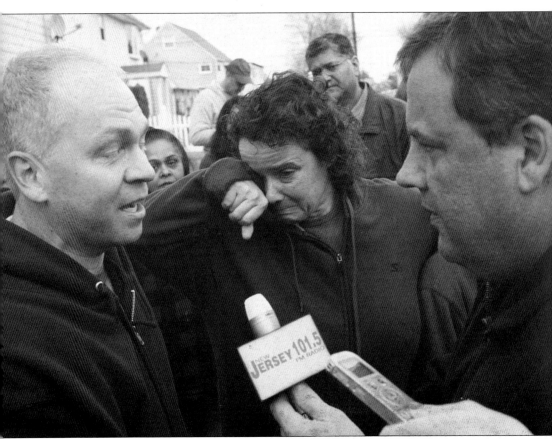

On November 1, 2012, the floodwaters had receded a day earlier, but the devastation was still clear as Governor Christie walked Moonachie roads lined with destroyed furniture, soggy carpets, and piles of garbage. Moonachie residents Michael and Annmarie Pansini spoke with Christie as he toured flood damage brought on by Hurricane Sandy's storm surge. He urged residents to seek relief aid from the Federal Emergency Management Agency (FEMA). (Photograph by Kevin R. Wexler; courtesy of the *Record* archives.)

After the storm, many groups from all over the world found ways to express their sorrow to the residents of North Jersey who endured Hurricane Sandy. Many organizations, from large corporations to the local Boy Scouts, did their civic duty to help the victims. Among them were rock stars and New Jersey natives Bruce Springsteen and Bon Jovi, who performed a benefit concert to help the victims of Superstorm Sandy. The event, billed as the Concert for Sandy Relief, was held at Madison Square Garden. In addition, on July 8, 2013, Bon Jovi presented Gov. Chris Christie and First Lady Mary Pat Christie with a $1 million donation to the Hurricane Sandy New Jersey Relief Fund. (Courtesy of the *Record* archives.)

ABOUT THE ORGANIZATION

North Jersey Media Group (North Jersey) is the leading provider of news and marketing services in northern New Jersey. The *Record* and its sister publication, *Herald News*, are award-winning daily newspapers that reach almost 500,000 readers a day with local, investigative, and enterprise reporting. NorthJersey.com is the number one website for local breaking news and bergen.com is the number one site dedicated to events and things to do in Bergen County. The sites combined have more than four million unique visitors. More than 40 community newspapers circulate to 670,000 households a week across Bergen, Passaic, Essex, Morris, and Sussex Counties. *(201)* magazine is the first—and only—monthly magazine for Bergen County, one of the country's wealthiest. *(201)* reaches the county's most affluent households with original editorial and exquisite photography that showcases influential people, estates, fashion, dining, and social events. Additional magazines reach the affluent audiences of Wayne, Millburn, Short Hills, and Montclair. Exposure , a specialty area that produces unique local events with mass appeal, offers clients innovative ways to reach current and prospective customers through unique live experiences and community showcases. The company's state-of-the-art, solar-powered plant prints all of its own newspapers and those of select other publishers.

The independent, family-owned company employs more than 1,000 people across 14 locations in North Jersey.

The North Jersey Media Group archives houses a diverse collection of images from over 40 publications serving the North Jersey area. Covering almost 142 years, the archive includes historical content from the *Paterson Evening News*, the *Record*, the *Call*, *Herald News*, and the *Ridgewood News* newspapers. The archives were maintained by many talented archivists, including Homer Martin (above left), who maintained and shaped the corporate library from 1961 to 1990. The photograph at right shows a librarian archiving newspapers on January 17, 1967, using the tools of the time: cutting board, cutting blade, and a date stamp. (Both, courtesy of the *Record* archives.)

Discover Thousands of Local History Books
Featuring Millions of Vintage Images

Arcadia Publishing, the leading local history publisher in the United States, is committed to making history accessible and meaningful through publishing books that celebrate and preserve the heritage of America's people and places.

Find more books like this at
www.arcadiapublishing.com

Search for your hometown history, your old stomping grounds, and even your favorite sports team.

Consistent with our mission to preserve history on a local level, this book was printed in South Carolina on American-made paper and manufactured entirely in the United States. Products carrying the accredited Forest Stewardship Council (FSC) label are printed on 100 percent FSC-certified paper.